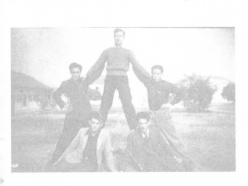
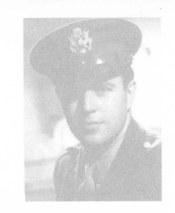
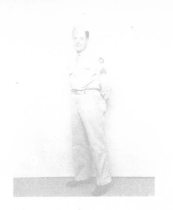
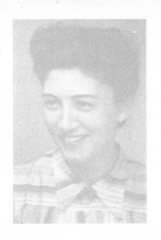
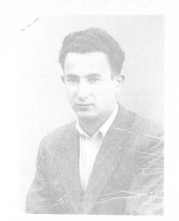

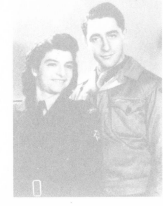
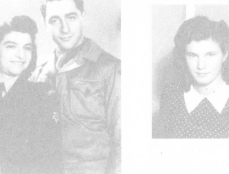
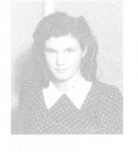
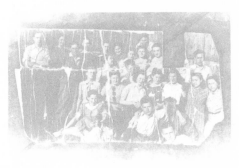
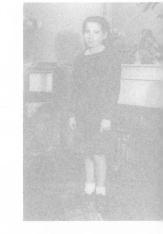
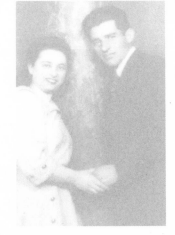

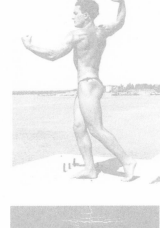
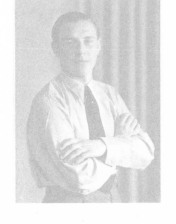
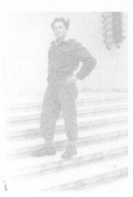
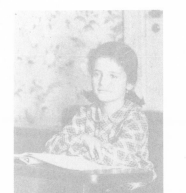
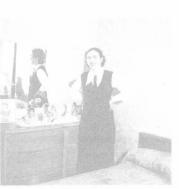

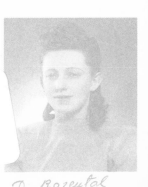

D. Rosenthal

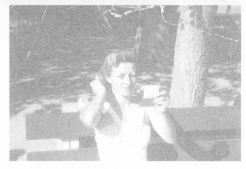
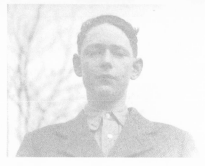

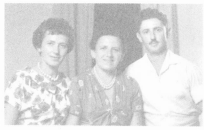
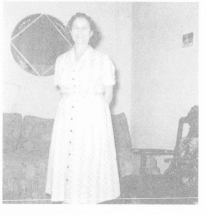
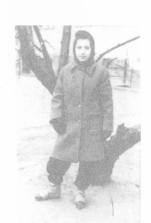
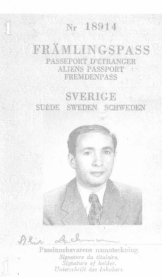
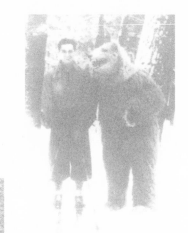
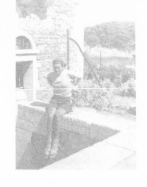
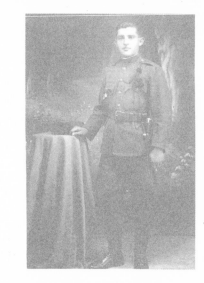
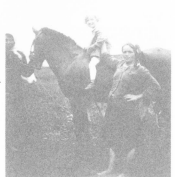
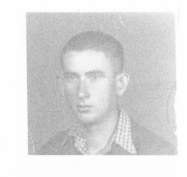
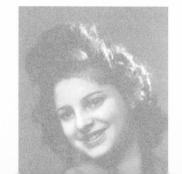
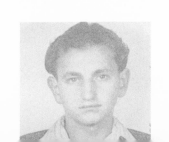
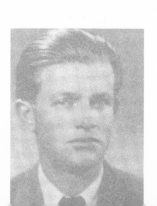

I was asked to send you some photographs of me before the Holocaust.

Sorry I have no photos like that as they were destroyed during the Nazi regime.

The first photo was taken by the Nazi Documentation Department at the death camp in Auschwitz.

I worked as a slave laborer, unloading incoming Jews and other minorities being brought to Auschwitz.

In this photograph, we are unloading a truck full of clothing and other articles

of Jews that were gassed upon arriving to Auschwitz.

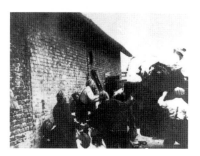

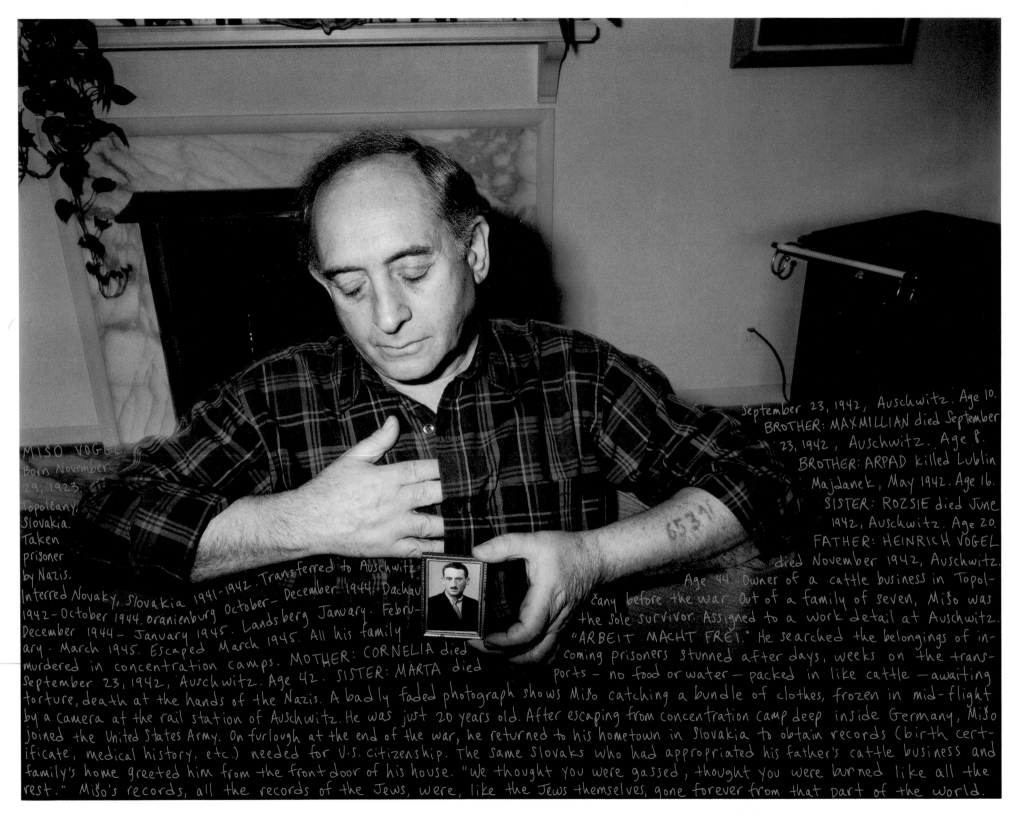

MISO VOGEL. Born November 29, 1923. Topolčany, Slovakia. Taken prisoner by Nazis. Interred Novaky, Slovakia 1941-1942. Transferred to Auschwitz December 1942-October 1944. oranienburg October-December 1944. Dachau December 1944-January 1945. Landsberg January. February. March 1945. Escaped March 1945. All his family murdered in concentration camps. MOTHER: CORNELIA died September 23, 1942, Auschwitz. Age 42. SISTER: MARTA died September 23, 1942, Auschwitz. Age 10. BROTHER: MAXMILLIAN died September 23, 1942, Auschwitz. Age 8. BROTHER: ARPAD killed Lublin Majdanek, May 1942. Age 16. SISTER: ROZSIE died June 1942, Auschwitz. Age 20. FATHER: HEINRICH VOGEL died November 1942, Auschwitz. Age 44. Owner of a cattle business in Topolčany before the war. Out of a family of seven, Mišo was the sole survivor. Assigned to a work detail at Auschwitz. "ARBEIT MACHT FREI." He searched the belongings of incoming prisoners stunned after days, weeks on the transports - no food or water - packed in like cattle - awaiting torture, death at the hands of the Nazis. A badly faded photograph shows Mišo catching a bundle of clothes, frozen in mid-flight by a camera at the rail station of Auschwitz. He was just 20 years old. After escaping from concentration camp deep inside Germany, Mišo joined the United States Army. On furlough at the end of the war, he returned to his hometown in Slovakia to obtain records (birth certificate, medical history, etc.) needed for U.S. citizenship. The same Slovaks who had appropriated his father's cattle business and family's home greeted him from the front door of his house. "We thought you were gassed, thought you were burned like all the rest." Mišo's records, all the records of the Jews, were, like the Jews themselves, gone forever from that part of the world.

MISO VOGEL

born 1923, Topolcany, Slovakia

WRITTEN IN MEMORY

Portraits of the Holocaust

Photographs by Jeffrey A. Wolin

Introduction by Charles Stainback

CHRONICLE BOOKS

SAN FRANCISCO

Published in conjunction with Catherine Edelman Gallery.

Library of Congress Cataloging-in-Publication Data:
Wolin, Jeffrey A.
 Written in memory : portraits of the Holocaust / photographs by
 Jeffrey A. Wolin; introduction by Charles Stainback.
 p. cm.
 ISBN 0-8118-1390-8 (hc) — ISBN 0-8118-1366-5 (pb)
 1. Holocaust, Jewish (1939-1945) — Personal narratives.
 2. Holocaust survivors — Portraits. I. Title
 D804.195.W65 1997
 940.53'18—DC20 96-22439
 CIP

Book Design by Jill Jacobson.

Printed in Hong Kong.

Distributed in Canada by
Raincoast Books
8680 Cambie Street
Vancouver, B.C. V6P 6M9

10 9 8 7 6 5 4 3 2 1

Chronicle Books
85 Second Street
San Francisco, CA 94105

Web Site: www.chronbooks.com

Memories are never anonymous

The Holocaust in its enormity defies language and art,

and yet both must be used to tell the tale,

the tale that must be told.

—*Elie Wiesel*

We all carry images around with us in our mind's eye or in our back pocket—documents of the conscious experience of our everyday lives. When we approach the photograph of a friend or a loved one, of a famous person or a compelling stranger, we come to it with decided expectations. Portraits most often reconfirm what we know and remember about a person. Or, in the case of a stranger, we try to find some identifiable, familiar characteristics from their expression, clothes, hairstyle, or body language. The photographic image triggers recollections of our past, bringing forth the emotions and words that can connect the forgotten history of the snapshot and our memory.

Photographic captions that explain the "reality" of the image distance the viewer from the image's content, no matter how dramatic, no matter how astonishing the representation. "Hundreds die in an earthquake/war/accident" scream the headlines, but what emotional response registers? When a photograph has no caption, almost anything can be true, especially in an age of computer technology. To caption a picture is to write history, but how far from history is fiction? More often than not, memory fades with the passage of time, and the caption is all that remains to clarify, identify, explain. Without a caption, interpretation is left to the imagination of the individual.

Jeff Wolin's portraits of Holocaust survivors throw the relationship of caption and image into stark relief. His work presents a doubled reflection: the photographic image as a surrogate for the person depicted, and the written word as a surrogate for that person's spoken words. Wolin calls our attention to the quality of both photographs and writing as representations—to speech and handwriting as traces of language, to the photograph as a fleeting moment in the life of the individual. His work thus forces us to go back and forth, reorganizing image and text—a process that requires us to stare into the stranger's eyes and think about not only what is pictured but also what is described. We read and look, feel and think, remember and want to forget. In a sense, these are historical photographs, yet they were made only recently with a simple grace and directness that—through a powerful combination of word and image—reveals the horror experienced by millions of people five decades ago.

6

Places of terror that we should never forget—

Auschwitz Stutthof Maidanek Treblinka

Theresienstadt Buchenwald Dachau Sachsenhausen

Ravensbrück Bergen-Belsen

—from a sign outside the Berlin Holocaust Memorial

George Santayana, the American philosopher, said "Those who forget the past are condemned to repeat it." This phrase could also describe the provocation for *Written in Memory: Portraits of the Holocaust*. Jeff Wolin's unassuming, eloquent images act as a poignant call for humanity to remember. His work incorporates a multitude of traditions: documentary photography, oral history, art photography, and fragmented narrative, and yet it is more than the sum of these parts. By means of this hybrid approach, Wolin reveals complex issues situated within an aesthetic and intellectual discourse. His multidimensional portraiture gives voice to the remarkable, complex, troubling histories that the world might find easier to forget.

Aleksandr Solzhenitsyn used an old Russian proverb—"Forget the past and you'll lose both eyes"—for the opening of his book, *Gulag Archipelago*; a thought that is parallel to Santayana's well-known pronouncement. For many of us, remembering the past is directly connected to seeing, and subsequently to photography, where the lens of the camera is the technical extension of human vision. With his forthright images and the uncensored stories that are written on them, Wolin forces us to experience and witness the haunting, unforgettable spectacle of humanity's evil. Seeing is believing. The recent celebration of the 50th anniversary of the end of World War II returned our attention to the horrific events that swept through Europe killing millions of people. Wolin's photographs remind us that with each subsequent anniversary there will be fewer and fewer eyewitnesses to one of the most tragic and incomprehensible periods in human history.

At the time of the first photographs of Nazi camps, there was

nothing banal about these images.

After thirty years, a saturation point may have been reached.

In these last decades, "concerned" photography has done as

much to deaden conscience as to arouse it. —*Susan Sontag*

These images are not documentary or photojournalistic images, nor can they be classified as "concerned" photography. They are historical accounts that convey not a saturation of violence, not a deadened conscience, but acute, vivid memories. As we read and gaze into the eyes of Wolin's subjects, what we see changes. We come to know their stories, their pain, their losses and tragedies on the most intimate of levels, one that verges upon the kinesthetic.

Jeff Wolin (born in 1951) could easily have been a traditional observer, a photographer dedicated to the finely crafted image. In the mid 1980s, however, he struck upon the device of writing his thoughts and memories on photographs he had made of his parents. This led to his larger project, which has compelled him to locate Holocaust survivors in his own town, Bloomington, as well as in Indianapolis, Chicago and its suburb Skokie, South Florida, and Paris, France. The survivors' experiences varied widely. While some were inmates of the camps, others had fled to America during Hitler's rise to power in Germany, or had been hidden throughout the war years.

Once Wolin finds his subjects, he interviews each one on videotape and only then makes the photograph. He transcribes the interviews, edits what he will use, and discusses his selections with the interviewees. Large areas of the final image are intentionally left void—blank walls, uncluttered spaces. In these spaces Wolin adds the handwritten text to the surface of the photograph.

Wolin's integration of image and text is unadorned. The handwriting he uses is legible but far from distinctive. The natural progression of the text within the composition works like an embrace—words wrapping around faces and bodies. The texture created by the words is neither beautiful nor neat, but it provides an integration of the whole that is conducive to reading and looking, feeling and thinking, remembering and regretting the past. Through these tableaux, spectators can examine instances of the most intimate and horrific extremes of human experience and suffering.

The straightforward, almost snapshotlike appearance of Wolin's photographs amplifies the immediate quality of the presentation. The texts are as close as possible to the actual words spoken. The text alone would be powerful and ghastly but would wield a fraction of the impact of Wolin's pictures with their handwritten inscriptions as you see them here. Neither flattering nor revealing, these portraits depict people at home, holding photographs, smoking at the kitchen table, or barefoot at the beach. Some people look squarely into the camera's lens while others seem lost in reverie. Eyes that look at first accusatory or hesitant become windows to very particular histories.

In one picture Tulek Forstenzer describes a simple scene from his experience in Mauthausen Concentration Camp in Austria. No more than a few sentences appear across the print describing how he would watch his fellow inmates load bodies into the ovens for the SS guards in the evening. The concluding line of his text—"Nobody figured they would get out alive"—is in thorough contrast to what we see. A pleasant-looking man in his late sixties with white cap, glasses, and casual attire sitting behind the wheel of his car. He strikes a pose, smiles warily, yet smiles all the same. In no way could we have imagined this and possibly the other stories that he has to tell.

The differences in human experience are the most astonishing aspect of Wolin's work. One survivor's first recollection is her desire to have been a grazing cow instead of a Jew, whereas another explains that after the war he moved to Germany to study "what kind of people is this that could do genocide like this." Another gives a chilling account of being told by the SS guard that "if you don't kill this fellow prisoner, we will kill you," while another says she is thankful she went to Auschwitz, because she does not have to endure the guilt of others having been there in her place. One woman recounts that she "realized it was the end of my childhood, and I was barely twelve years old." The impact of the war is most powerfully related through the most intimate recollection. In an age in which the sound bite is synonymous with the constant visual hum of modern life, Wolin gives us immediacy in his portraits of Holocaust survivors. The images' texts are not headlines, not captions, not even descriptions, but rather carefully distilled eyewitness accounts of history and experience. In standing before the camera and speaking for the record, these people bear witness in personal and reflective terms for themselves and for generations to come.

— CHARLES STAINBACK *April, 1996*

To the memory of my grandparents: Sam Fuchsman (Lublin, Poland), Bella Fuchsman, née Weissbrot (Cycow, Poland), and Rebecca Wolishinsky, née Abovitz (Vilna, Lithuania).

When I was a child they shared with me their recollections of an ancient culture in far-off lands and a distant past.

Before the war, Warsaw, Poland

RENA GRYNBLAT

born 1926, Warsaw, Poland

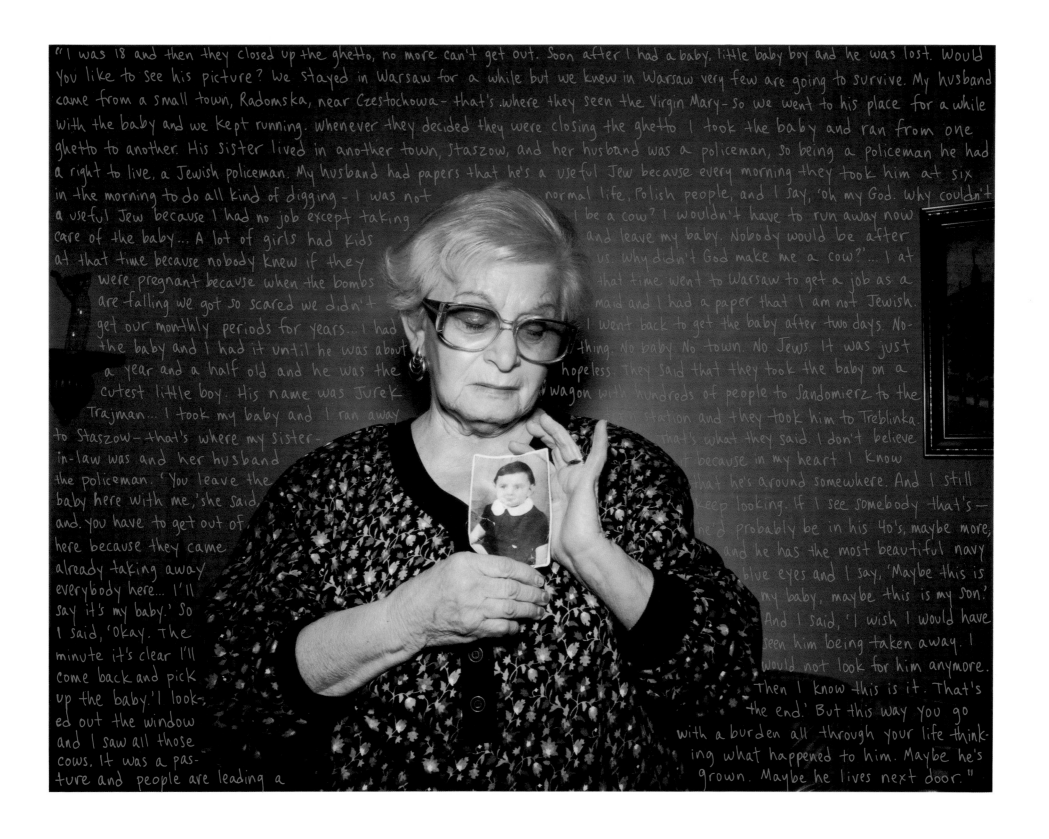

"I was 18 and then they closed up the ghetto, no more can't get out. Soon after I had a baby, little baby boy and he was lost. Would you like to see his picture? We stayed in Warsaw for a while but we knew in Warsaw very few are going to survive. My husband came from a small town, Radomska, near Czestochowa—that's where they seen the Virgin Mary—so we went to his place for a while with the baby and we kept running. Whenever they decided they were closing the ghetto I took the baby and ran from one ghetto to another. His sister lived in another town, Staszow, and her husband was a policeman, so being a policeman he had a right to live, a Jewish policeman. My husband had papers that he's a useful Jew because every morning they took him at six in the morning to do all kind of digging—I was not a useful Jew because I had no job except taking care of the baby... A lot of girls had kids at that time because nobody knew if they were pregnant because when the bombs are falling we got so scared we didn't get our monthly periods for years... I had the baby and I had it until he was about a year and a half old and he was the cutest little boy. His name was Jurek Trajman... I took my baby and I ran away to Staszow—that's where my sister-in-law was and her husband the policeman. 'You leave the baby here with me,' she said and you have to get out of here because they came already taking away everybody here... I'll say it's my baby.' So I said, 'Okay. The minute it's clear I'll come back and pick up the baby.' I look-ed out the window and I saw all those cows. It was a pas-ture and people are leading a normal life, Polish people, and I say, 'oh my God, why couldn't I be a cow? I wouldn't have to run away now and leave my baby. Nobody would be after us. Why didn't God make me a cow?'... I at that time went to Warsaw to get a job as a maid and I had a paper that I am not Jewish. I went back to get the baby after two days. No-thing. No baby. No town. No Jews. It was just hopeless. They said that they took the baby on a wagon with hundreds of people to Sandomierz to the station and they took him to Treblinka. That's what they said. I don't believe it because in my heart I know that he's around somewhere. And I still keep looking. If I see somebody that's—he'd probably be in his 40's, maybe more; and he has the most beautiful navy blue eyes and I say, 'Maybe this is my baby, maybe this is my son.' And I said, 'I wish I would have seen him being taken away. I would not look for him anymore. Then I know this is it. That's the end.' But this way you go with a burden all through your life think-ing what happened to him. Maybe he's grown. Maybe he lives next door."

(right) *Landsberg, Germany, 1947*

(below) *Polish Ski Association, Carpathian Mountains, Poland, 1938*

MIECZYSLAW WEINBERG

born 1912, Warsaw, Poland

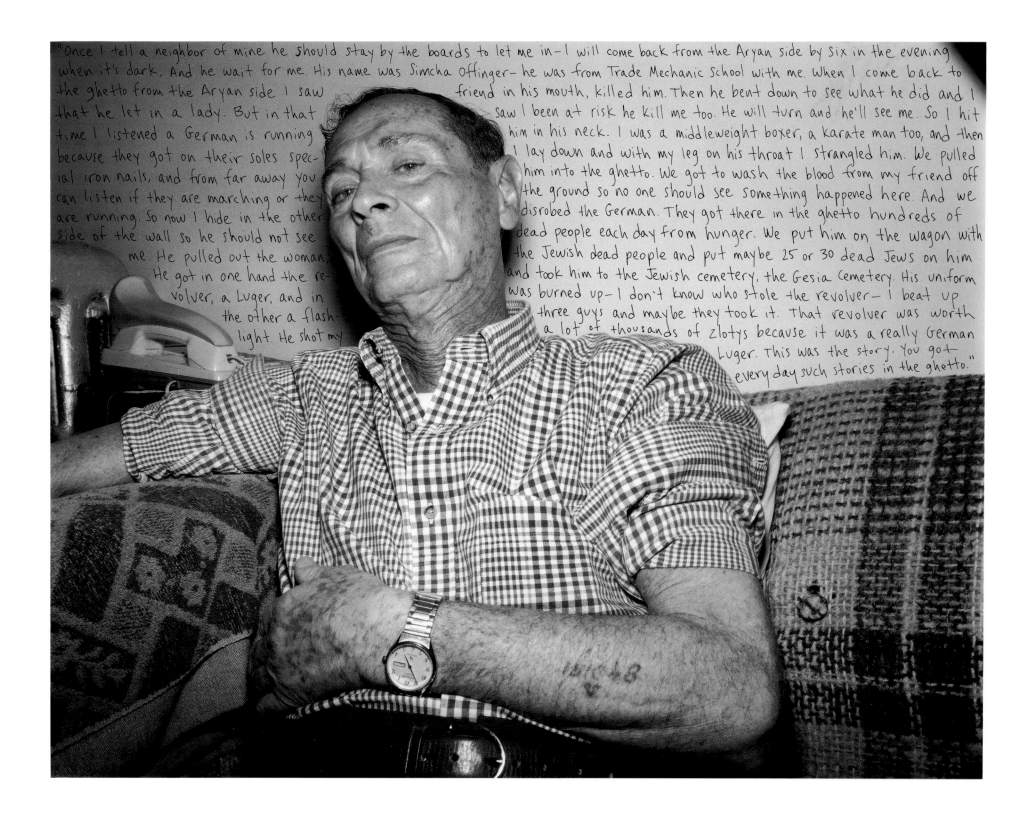

"Once I tell a neighbor of mine he should stay by the boards to let me in—I will come back from the Aryan side by six in the evening when it's dark. And he wait for me. His name was Simcha Offinger—he was from Trade Mechanic School with me. When I come back to the ghetto from the Aryan side I saw that he let in a lady. But in that time I listened a German is running because they got on their soles special iron nails, and from far away you can listen if they are marching or they are running. So now I hide in the other side of the wall so he should not see me. He pulled out the woman. He got in one hand the revolver, a Luger, and in the other a flashlight. He shot my friend in his mouth, killed him. Then he bent down to see what he did and I saw I been at risk he kill me too. He will turn and he'll see me. So I hit him in his neck. I was a middleweight boxer, a karate man too, and then I lay down and with my leg on his throat I strangled him. We pulled him into the ghetto. We got to wash the blood from my friend off the ground so no one should see something happened here. And we disrobed the German. They got there in the ghetto hundreds of dead people each day from hunger. We put him on the wagon with the Jewish dead people and put maybe 25 or 30 dead Jews on him and took him to the Jewish cemetery, the Gesia cemetery. His uniform was burned up—I don't know who stole the revolver—I beat up three guys and maybe they took it. That revolver was worth a lot of thousands of zlotys because it was a really German Luger. This was the story. You got every day such stories in the ghetto."

October 1944, after the liberation of Paris

HELGA LESSER

born 1926, Berlin, Germany (fled to Paris in 1938)

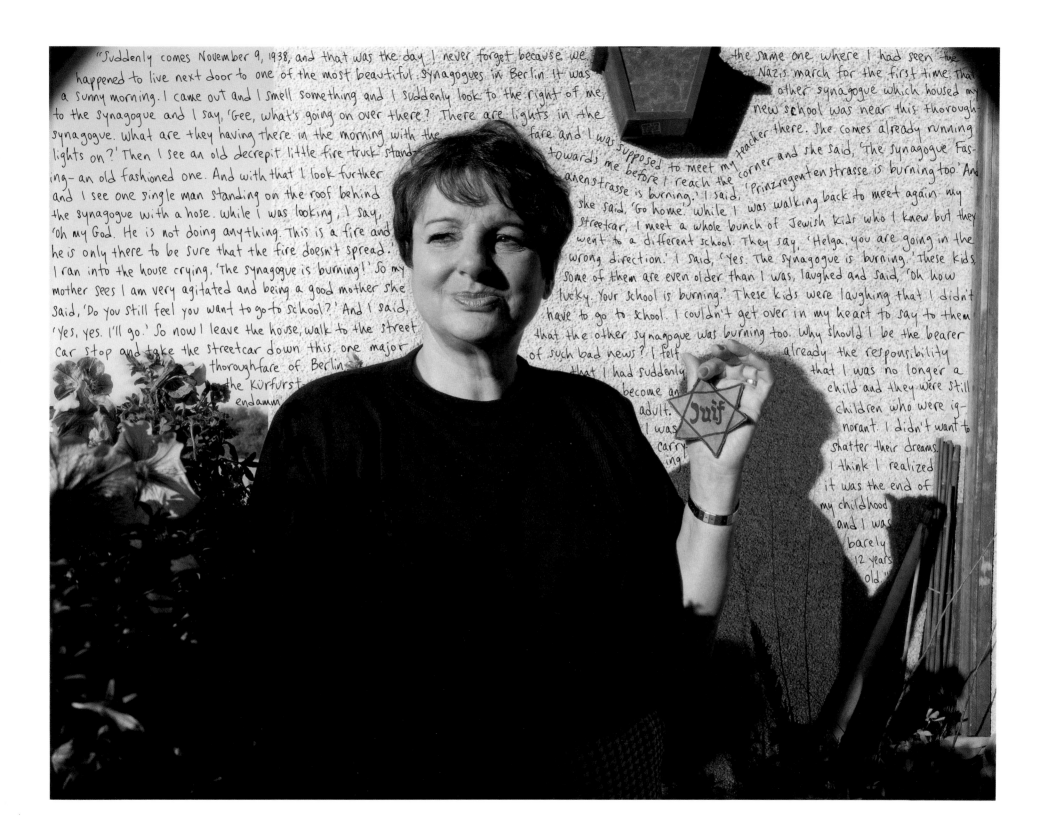

"Suddenly comes November 9, 1938, and that was the day I never forget because we happened to live next door to one of the most beautiful synagogues in Berlin. It was a sunny morning. I came out and I smell something and I suddenly look to the right of me, to the synagogue and I say, 'Gee, what's going on over there? There are lights in the synagogue. What are they having there in the morning with the lights on?' Then I see an old decrepit little fire-truck standing— an old fashioned one. And with that I look further and I see one single man standing on the roof behind the synagogue with a hose. While I was looking, I say, 'Oh my God. He is not doing anything. This is a fire and he is only there to be sure that the fire doesn't spread.' I ran into the house crying, 'The synagogue is burning!' So my mother sees I am very agitated and being a good mother she said, 'Do you still feel you want to go to school?' And I said, 'Yes, yes. I'll go.' So now I leave the house, walk to the street car stop and take the streetcar down this one major thoroughfare of Berlin the Kürfürst endamm

fare and I was supposed to meet my teacher towards me before I reach the corner and she said, 'The synagogue Fasanenstrasse is burning.' I said, 'Prinzregentenstrasse is burning too.' And she said, 'Go home.' While I was walking back to meet again my streetcar, I meet a whole bunch of Jewish kids who I knew but they went to a different school. They say, 'Helga, you are going in the wrong direction.' I said, 'Yes. The synagogue is burning.' These kids, some of them are even older than I was, laughed and said, 'Oh how lucky. Your school is burning.' These kids were laughing that I didn't have to go to school. I couldn't get over in my heart to say to them that the other synagogue was burning too. Why should I be the bearer of such bad news? I felt that I had suddenly become an adult. I was carrying

the same one where I had seen the Nazis march for the first time. That other synagogue which housed my new school was near this thoroughfare there. She comes already running and she said, 'The synagogue Fasanenstrasse is burning.' I said, 'Prinzregentenstrasse is burning too.' And she said, 'Go home.' While I was walking back to meet again my already the responsibility that I was no longer a child and they were still children who were ignorant. I didn't want to shatter their dreams. I think I realized it was the end of my childhood and I was barely 12 years old."

Honolulu, Fall 1956

CLARA WEISS

born 1923, Dovhe, Slovakia

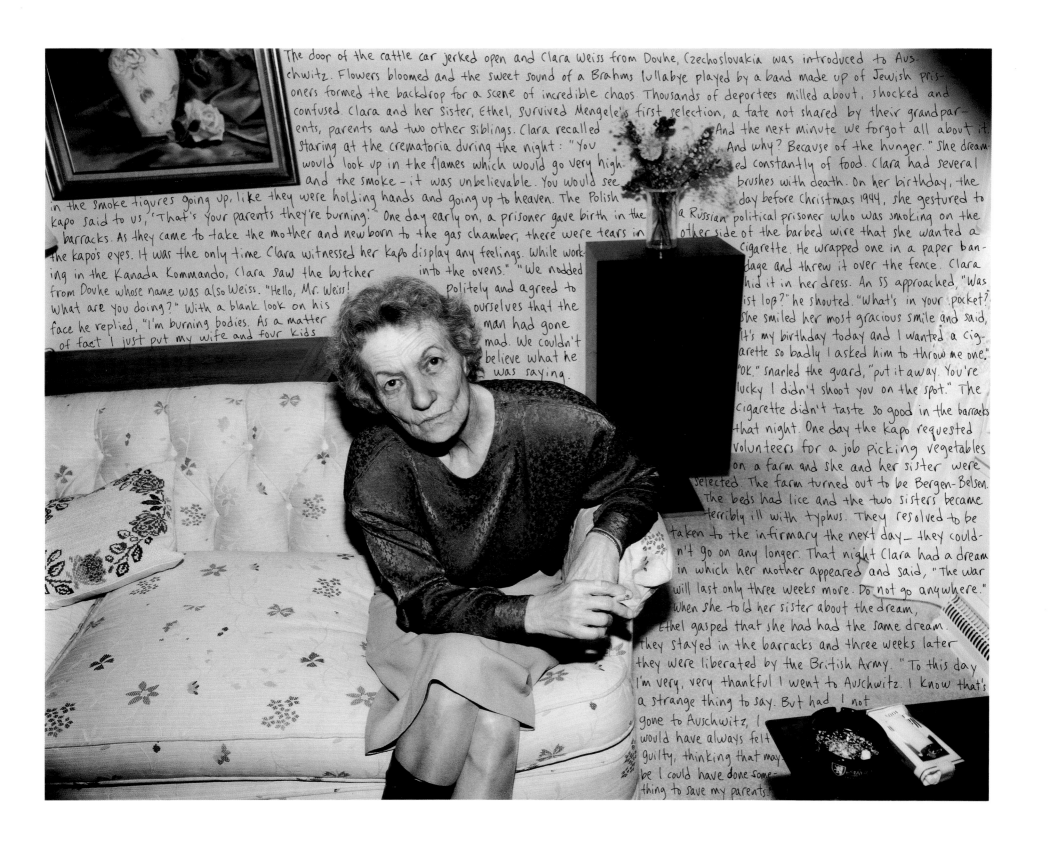

The door of the cattle car jerked open and Clara Weiss from Dovhe, Czechoslovakia was introduced to Auschwitz. Flowers bloomed and the sweet sound of a Brahms lullabye played by a band made up of Jewish prisoners formed the backdrop for a scene of incredible chaos. Thousands of deportees milled about, shocked and confused. Clara and her sister, Ethel, survived Mengele's first selection, a fate not shared by their grandparents, parents and two other siblings. Clara recalled staring at the crematoria during the night: "You would look up in the flames which would go very high and the smoke - it was unbelievable. You would see in the smoke figures going up, like they were holding hands and going up to heaven. The Polish kapo said to us, 'That's your parents they're burning.'" One day early on, a prisoner gave birth in the barracks. As they came to take the mother and newborn to the gas chamber, there were tears in the kapo's eyes. It was the only time Clara witnessed her kapo display any feelings. While working in the Kanada Kommando, Clara saw the butcher from Dovhe whose name was also Weiss. "Hello, Mr. Weiss! What are you doing?" With a blank look on his face he replied, "I'm burning bodies. As a matter of fact I just put my wife and four kids into the ovens." "We nodded politely and agreed to ourselves that the man had gone mad. We couldn't believe what he was saying.

And the next minute we forgot all about it. And why? Because of the hunger." She dreamed constantly of food. Clara had several brushes with death. On her birthday, the day before Christmas 1944, she gestured to a Russian political prisoner who was smoking on the other side of the barbed wire that she wanted a cigarette. He wrapped one in a paper bandage and threw it over the fence. Clara hid it in her dress. An SS approached, "Was ist los?" he shouted. "What's in your pocket?" She smiled her most gracious smile and said, "It's my birthday today and I wanted a cigarette so badly I asked him to throw me one." "OK," snarled the guard, "put it away. You're lucky I didn't shoot you on the spot." The cigarette didn't taste so good in the barracks that night. One day the kapo requested volunteers for a job picking vegetables on a farm and she and her sister were selected. The farm turned out to be Bergen-Belsen. The beds had lice and the two sisters became terribly ill with typhus. They resolved to be taken to the infirmary the next day— they couldn't go on any longer. That night Clara had a dream in which her mother appeared and said, "The war will last only three weeks more. Do not go anywhere." When she told her sister about the dream, Ethel gasped that she had had the same dream. They stayed in the barracks and three weeks later they were liberated by the British Army. "To this day I'm very, very thankful I went to Auschwitz. I know that's a strange thing to say. But had I not gone to Auschwitz, I would have always felt guilty, thinking that maybe I could have done something to save my parents."

Boras, Sweden, 1948

AL LACHMAN

born 1918, Praszka, Poland

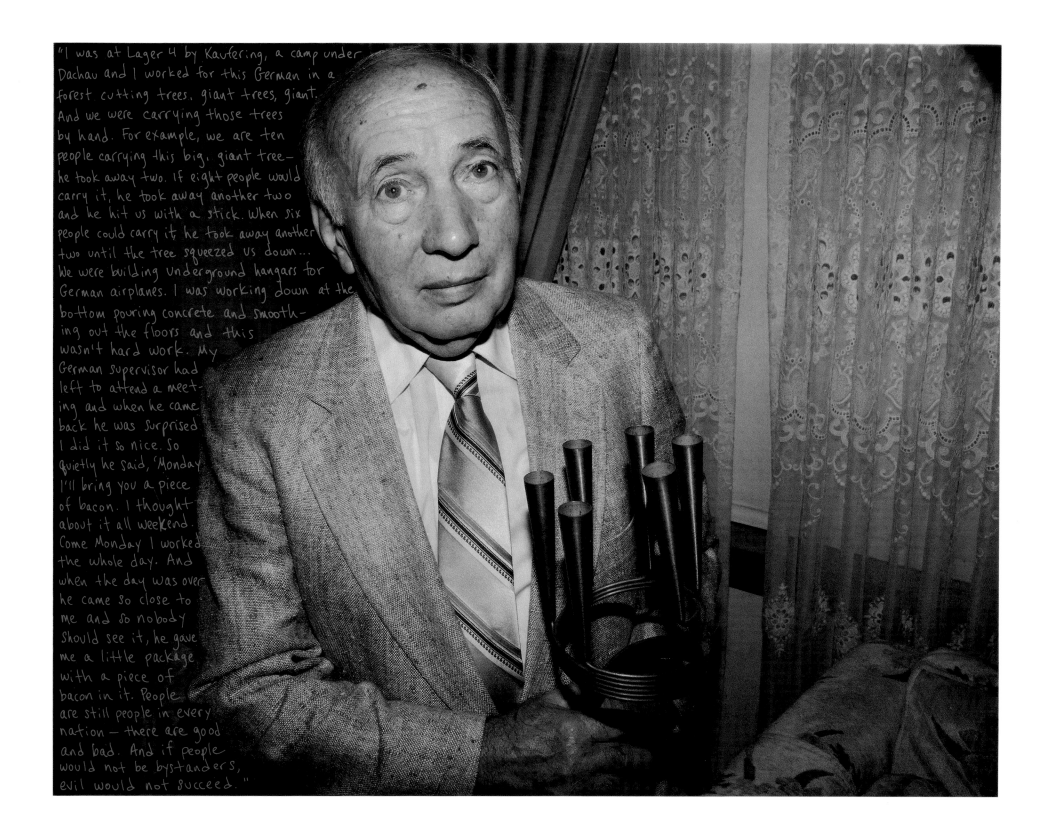

"I was at Lager 4 by Kaufering, a camp under Dachau and I worked for this German in a forest cutting trees, giant trees, giant. And we were carrying those trees by hand. For example, we are ten people carrying this big, giant tree— he took away two. If eight people would carry it, he took away another two and he hit us with a stick. When six people could carry it he took away another two until the tree squeezed us down... We were building underground hangars for German airplanes. I was working down at the bottom pouring concrete and smooth- ing out the floors and this wasn't hard work. My German supervisor had left to attend a meet- ing and when he came back he was surprised I did it so nice. So quietly he said, 'Monday I'll bring you a piece of bacon. I thought about it all weekend. Come Monday I worked the whole day. And when the day was over he came so close to me and so nobody should see it, he gave me a little package with a piece of bacon in it. People are still people in every nation — there are good and bad. And if people would not be bystanders, evil would not succeed."

Doctors in Vienna pronounced my whooping cough incurable and told my mother that I was dying.
Following an old Jewish superstition, my mother took me to her parents' farm in Poland
where she "sold" me to my grandmother so that I could have a new life.
The women in the picture were peasants who worked on the farm.
I was three in this picture.

ALICE FRIEDMAN

born 1934, Vienna, Austria

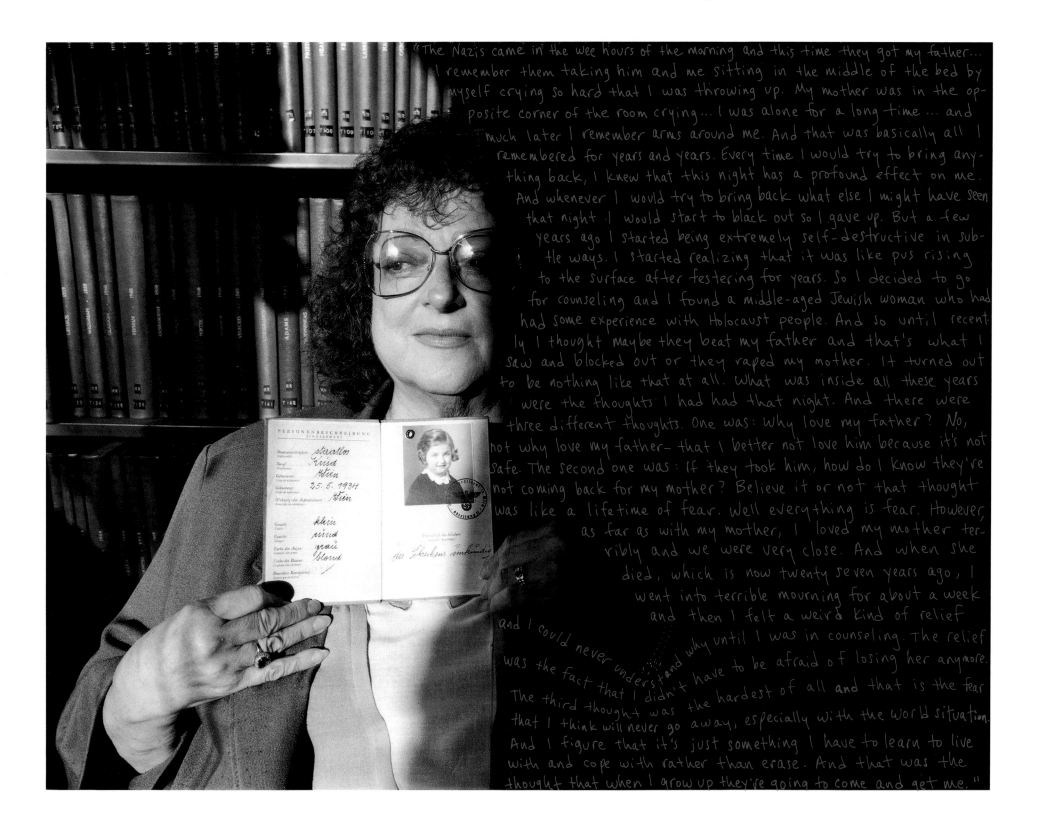

"The Nazis came in the wee hours of the morning and this time they got my father... I remember them taking him and me sitting in the middle of the bed by myself crying so hard that I was throwing up. My mother was in the opposite corner of the room crying... I was alone for a long time ... and much later I remember arms around me. And that was basically all I remembered for years and years. Every time I would try to bring anything back, I knew that this night has a profound effect on me. And whenever I would try to bring back what else I might have seen that night I would start to black out so I gave up. But a few years ago I started being extremely self-destructive in subtle ways. I started realizing that it was like pus rising to the surface after festering for years. So I decided to go for counseling and I found a middle-aged Jewish woman who had had some experience with Holocaust people. And so until recently I thought maybe they beat my father and that's what I saw and blocked out or they raped my mother. It turned out to be nothing like that at all. What was inside all these years were the thoughts I had had that night. And there were three different thoughts. One was: Why love my father? No, not why love my father— that I better not love him because it's not safe. The second one was: if they took him, how do I know they're not coming back for my mother? Believe it or not that thought was like a lifetime of fear. Well everything is fear. However, as far as with my mother, I loved my mother terribly and we were very close. And when she died, which is now twenty seven years ago, I went into terrible mourning for about a week and then I felt a weird kind of relief and I could never understand why until I was in counseling. The relief was the fact that I didn't have to be afraid of losing her anymore. The third thought was the hardest of all and that is the fear that I think will never go away, especially with the world situation. And I figure that it's just something I have to learn to live with and cope with rather than erase. And that was the thought that when I grow up they're going to come and get me."

Circa 1945, Warsaw, Poland

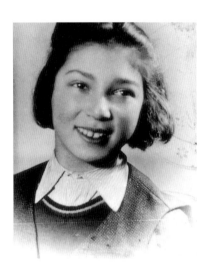

Irma Morgensztern

born 1933, Warsaw, Poland

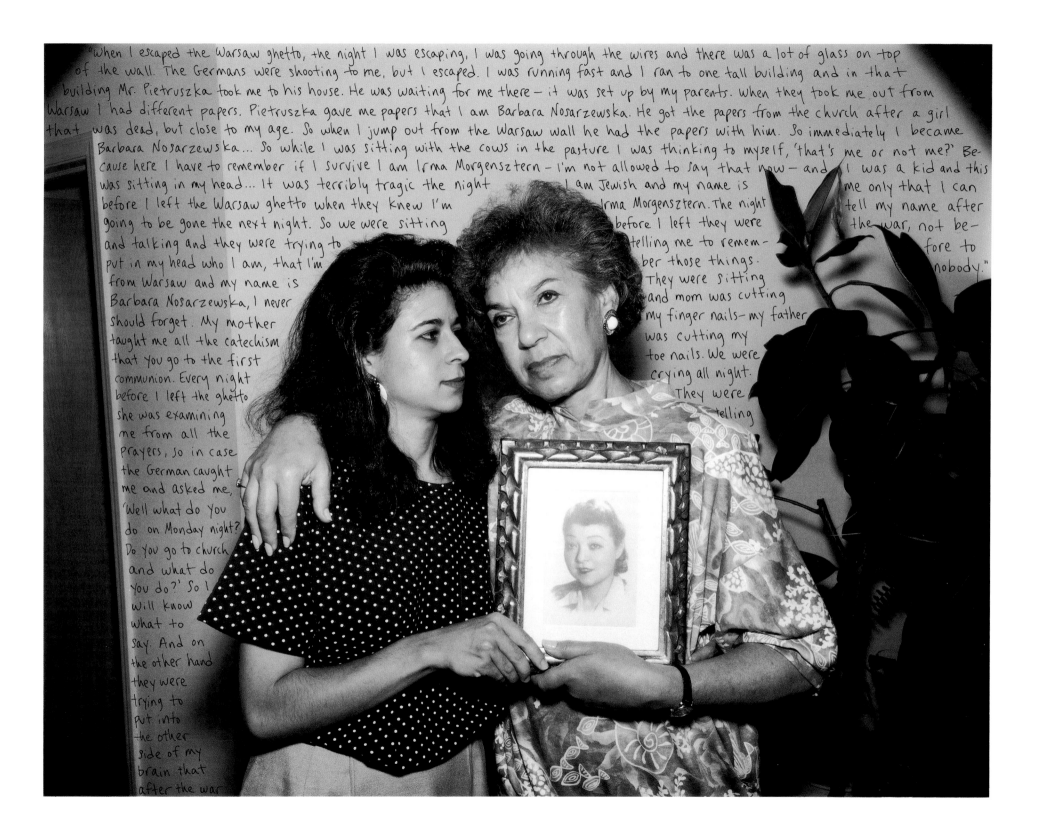

"when I escaped the Warsaw ghetto, the night I was escaping, I was going through the wires and there was a lot of glass on top of the wall. The Germans were shooting to me, but I escaped. I was running fast and I ran to one tall building and in that building Mr. Pietruszka took me to his house. He was waiting for me there — it was set up by my parents. when they took me out from Warsaw I had different papers. Pietruszka gave me papers that I am Barbara Nosarzewska. He got the papers from the church after a girl that was dead, but close to my age. So when I jump out from the Warsaw wall he had the papers with him. So immediately I became Barbara Nosarzewska... So while I was sitting with the cows in the pasture I was thinking to myself, 'that's me or not me?' Because here I have to remember if I survive I am Irma Morgensztern — I'm not allowed to say that now — and I was a kid and this was sitting in my head... It was terribly tragic the night I am Jewish and my name is me only that I can before I left the Warsaw ghetto when they knew I'm Irma Morgensztern. The night tell my name after going to be gone the next night. So we were sitting before I left they were the war, not be- and talking and they were trying to telling me to remem- fore to put in my head who I am, that I'm ber those things. nobody." from Warsaw and my name is They were sitting Barbara Nosarzewska, I never and mom was cutting should forget. My mother my finger nails — my father taught me all the catechism was cutting my that you go to the first toe nails. We were communion. Every night crying all night. before I left the ghetto They were she was examining telling me from all the prayers, so in case the German caught me and asked me, 'Well what do you do on Monday night? Do you go to church and what do you do?' So I will know what to say. And on the other hand they were trying to put into the other side of my brain that after the war

Celcee, 1943. Me on right on a visit home from Budapest,
with brother Sam, now seventy-one, recently arrived
in Israel from the U.S.S.R. Sam is an Auschwitz (and other camps) survivor.
The two sisters in photo perished in Auschwitz.

MAYLECH BLOBSTEIN

born 1928, Celcee, Hungary

When Maylech graduated from the eighth grade, his parents sent him to Budapest to become an apprentice in the leather goods trade. He was fourteen years old when he took up residence in a Jewish Community Home for young apprentices in 1942. For the next two years life in Budapest proceeded somewhat normally.

In March 1944, however, Adolf Eichmann arrived in Budapest at the head of the German Army. Shortly thereafter, Maylech and the other boys were rounded up and taken to another home in Budapest. The city was being bombed three times a day by the Allies, and Maylech and the other Jewish children cleaned up rubble from buildings hit by bombs. They were watched by the Arrow Cross Fascist Militia, who often stormed into the house and beat the children.

In November Maylech and the other Jewish boys were marched to the Russian front some fifty miles east of Budapest. They dug trenches for the German Army as sounds of battle raged nearby.

On Christmas eve the boys were taken by the Arrow Cross and marched across the Danube from Pest to Buda, headed for Austria along with hundreds of other Jewish prisoners. German soldiers overtook them and shouted frantically at the guards to return the prisoners to the ghetto—the city was surrounded by the Russian Army. The Jews were then divided into two groups. Through a misunderstanding, Maylech's group was taken not to the ghetto but rather to an abandoned building in another part of town. They were turned over to Hungarian soldiers who were actually Jewish infiltrators. They protected the boys until the fierce house-to-house combat was over. Maylech was liberated by the Russians on January 15, 1945. The other group of Jews, Maylech found out, was marched to the Danube, lined up, shot, and their bodies dumped into the river.

Maylech's home region of Carpathia now became part of the Soviet Union. Open borders began to close as the Iron Curtain fell. In January 1946, Maylech and four countrymen decided to escape to the West. They traveled to Ungvar and hired a couple of smugglers who had farms on the border to take them to Czechoslovakia. On a snowy winter night they divided into two groups. Three in the first wagon took off for the border while Maylech and another boy in the second wagon were delayed because their horse refused to budge in the snow. Their friends in the first group were detained by guards. A few minutes later Maylech slipped across the border into Czechoslovakia.

With friend, David Berger, Budapest, 1945, soon after liberation.
David was trapped in the Soviet Union for forty-five years.
We were recently reunited in Brooklyn.

24

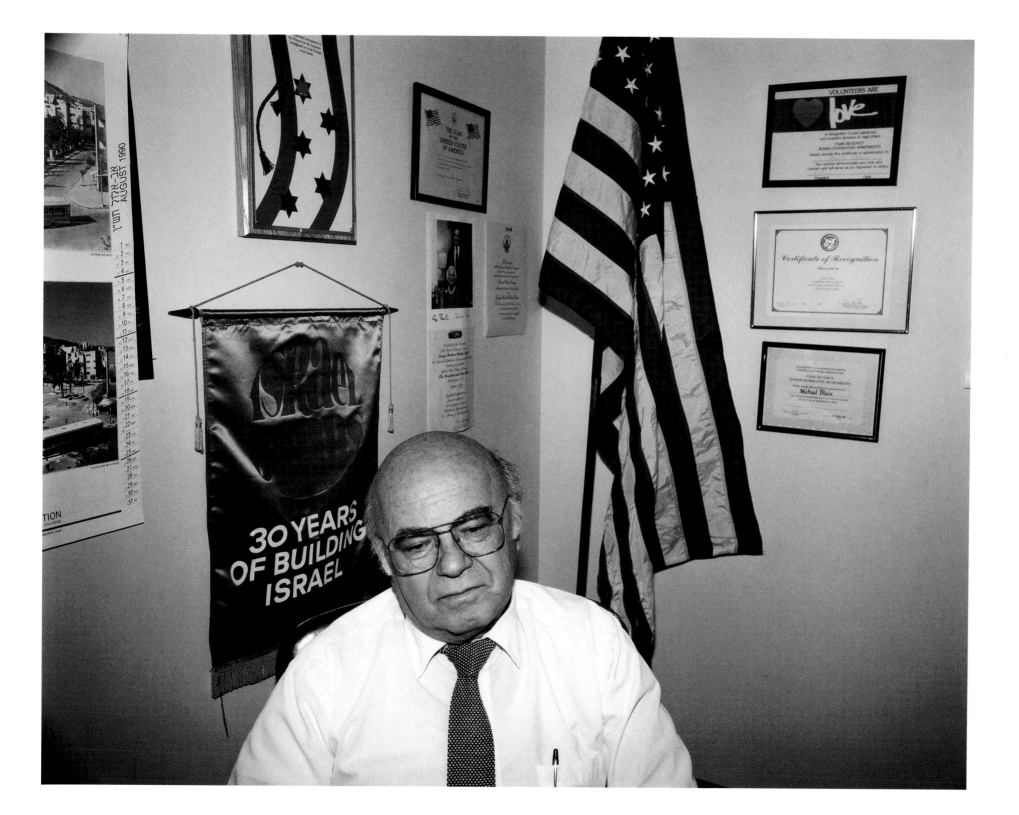

Landsberg, Germany, 1947

ELIASZ OLEWNIK

born 1930, Zuromin, Poland

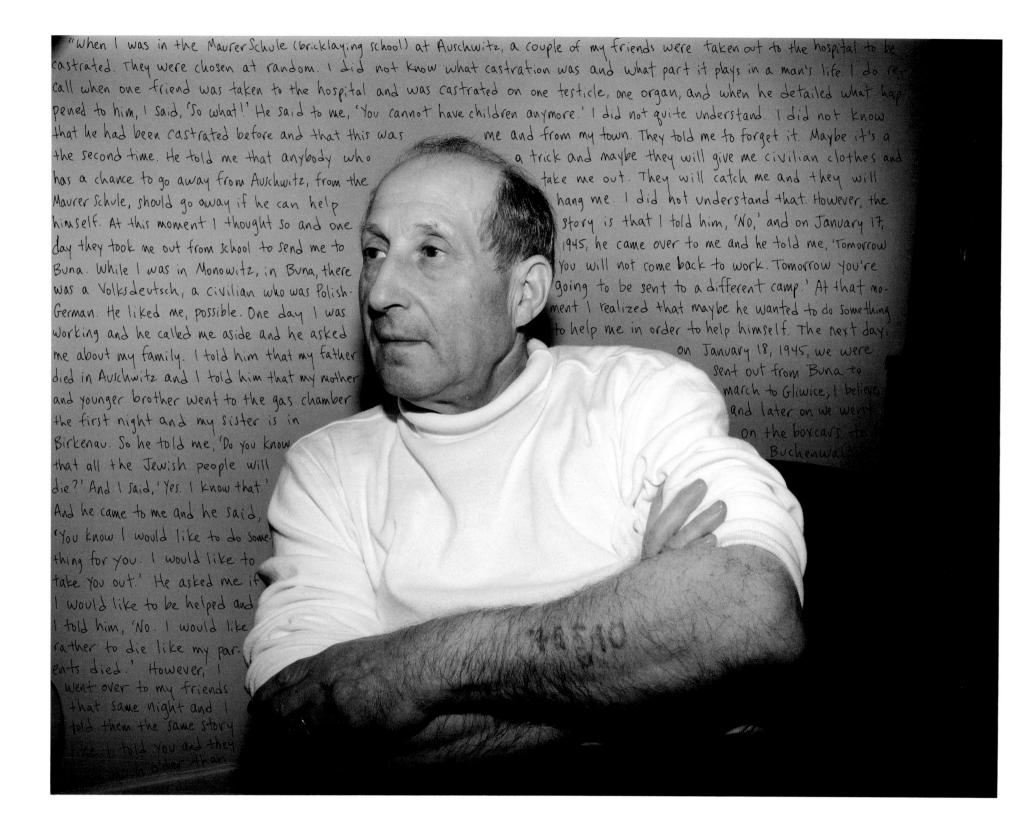

"When I was in the Maurer Schule (bricklaying school) at Auschwitz, a couple of my friends were taken out to the hospital to be castrated. They were chosen at random. I did not know what castration was and what part it plays in a man's life. I do recall when one friend was taken to the hospital and was castrated on one testicle, one organ, and when he detailed what happened to him, I said, 'So what!' He said to me, 'You cannot have children anymore.' I did not quite understand. I did not know that he had been castrated before and that this was the second time. He told me that anybody who has a chance to go away from Auschwitz, from the Maurer Schule, should go away if he can help himself. At this moment I thought so and one day they took me out from school to send me to Buna. While I was in Monowitz, in Buna, there was a Volksdeutsch, a civilian who was Polish-German. He liked me, possible. One day I was working and he called me aside and he asked me about my family. I told him that my father died in Auschwitz and I told him that my mother and younger brother went to the gas chamber the first night and my sister is in Birkenau. So he told me, 'Do you know that all the Jewish people will die?' And I said, 'Yes. I know that.' And he came to me and he said, 'You know I would like to do something for you. I would like to take you out.' He asked me if I would like to be helped and I told him, 'No. I would like rather to die like my parents died.' However, I went over to my friends that same night and I told them the same story like I told you and they [were older than]

me and from my town. They told me to forget it. Maybe it's a trick and maybe they will give me civilian clothes and take me out. They will catch me and they will hang me. I did not understand that. However, the story is that I told him, 'No,' and on January 17, 1945, he came over to me and he told me, 'Tomorrow you will not come back to work. Tomorrow you're going to be sent to a different camp.' At that moment I realized that maybe he wanted to do something to help me in order to help himself. The next day, on January 18, 1945, we were sent out from Buna to march to Gliwice, I believe, and later on we went on the boxcars to Buchenwald."

When I was seventeen (just like in the song by Frank Sinatra, you know!). Paris, 1947.

SAKO HOFFMAN

born 1930, Buenos Aires, Argentina (moved to Paris in 1932)

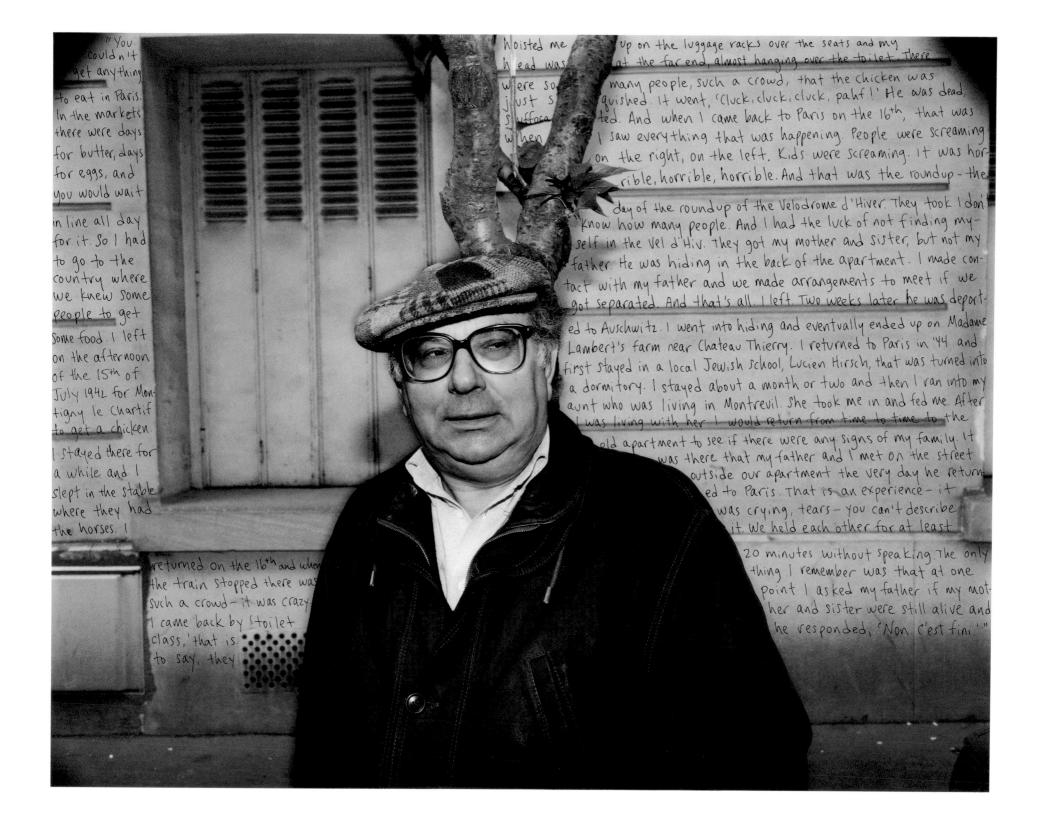

"You couldn't get anything to eat in Paris. In the markets there were days for butter, days for eggs, and you would wait in line all day for it. So I had to go to the country where we knew some people to get some food. I left on the afternoon of the 15th of July 1942 for Montigny le Chartif to get a chicken. I stayed there for a while and I slept in the stable where they had the horses. I

returned on the 16th and when the train stopped there was such a crowd - it was crazy. I came back by 'toilet class,' that is to say, they

hoisted me up on the luggage racks over the seats and my head was just so suffocated up on the luggage racks over the seats and my head was at the far end, almost hanging over the toilet. There were so many people, such a crowd, that the chicken was just squished. It went, 'Cluck, cluck, cluck, pahf!' He was dead, suffocated. And when I came back to Paris on the 16th, that was when I saw everything that was happening. People were screaming on the right, on the left. Kids were screaming. It was horrible, horrible, horrible. And that was the roundup - the day of the roundup of the Velodrome d'Hiver. They took I don't know how many people. And I had the luck of not finding myself in the Vel d'Hiv. they got my mother and sister, but not my father. He was hiding in the back of the apartment. I made contact with my father and we made arrangements to meet if we got separated. And that's all. I left. Two weeks later he was deported to Auschwitz. I went into hiding and eventually ended up on Madame Lambert's farm near Chateau Thierry. I returned to Paris in '44 and first stayed in a local Jewish school, Lucien Hirsch, that was turned into a dormitory. I stayed about a month or two and then I ran into my aunt who was living in Montrevil. She took me in and fed me. After I was living with her I would return from time to time to the old apartment to see if there were any signs of my family. It was there that my father and I met on the street outside our apartment the very day he returned to Paris. That is an experience - it was crying, tears - you can't describe it. We held each other for at least

20 minutes without speaking. The only thing I remember was that at one point I asked my father if my mother and sister were still alive and he responded, 'Non. C'est fini!'"

ANDRAS LENARD

born 1927, Debrecen, Hungary

When the German Army occupied Debrecen in March 1944, Jews were given twenty-four hours to pack their belongings and move to a ghetto that had been cordoned off in town.

The Lenard home, which was large and well-appointed, became Gestapo headquarters. In mid-June the Nazis ordered that the ghetto be evacuated. While the Jews were marched through the streets to a brickyard where they were to be temporarily imprisoned, a large crowd of townspeople gathered to watch. Some cursed the Jews; others yelled "At last, the Jews are taken to the cemetery." But there were crying faces as well. Andras felt exposed to the crowd's gaze like an animal being led to slaughter. Somewhere around this time, Mrs. Eszenyi, a close family friend, took a drug overdose. Andras watched her die a slow and painful death in the dust of the brickyard.

After a week or so at the brick factory, the Jews were put onto a train of overloaded cattle cars, 70–100 people per wagon. The three-day journey was an experience of horror. When the train finally stopped, he was one of several prisoners ordered to rush down the platform with buckets to fetch water for the others. Bent over the faucet, Andras drank and drank. The exquisite relief from three days of thirst was something he never forgot.

The train rolled on to Strasshof, a camp outside Vienna, where Andras, two siblings, and their mother were eventually interned. Andras was a slave laborer for Sager und Worner, a civilian construction company, until his liberation by the Russian Army on April 10, 1945.

After the war Andras learned that he had been part of a contingent of Jews that Adolf Eichmann attempted to trade for trucks and other supplies with a Jewish organization in Budapest. Three thousand Jews from Gyor were supposed to be transported to Austria to be "laid on ice" until the deal with the Jewish Rescue Committee was closed. Due to a clerical error, the Jews from Gyor wound up at Auschwitz. Andras' train from Debrecen, which was destined for Auschwitz, was sent on to Strasshof in their stead. The numbers of the two trains were simply interchanged to compensate for the mistake.

Taken in 1945 after the war in Santa-Katarina, Italy.

The Jewish Brigade from Israel organized survivors at various railroad stations to take us to Israel.

We were first taken to Santa-Katarina, then on to Bari, Italy.

In the meantime, my uncle in Brooklyn, New York sent an affidavit to me to come to the United States,

which precluded my going to Israel. I arrived in the United States in 1952.

MOSES WLOSKI

born 1921, Wolkowisk, White Russia

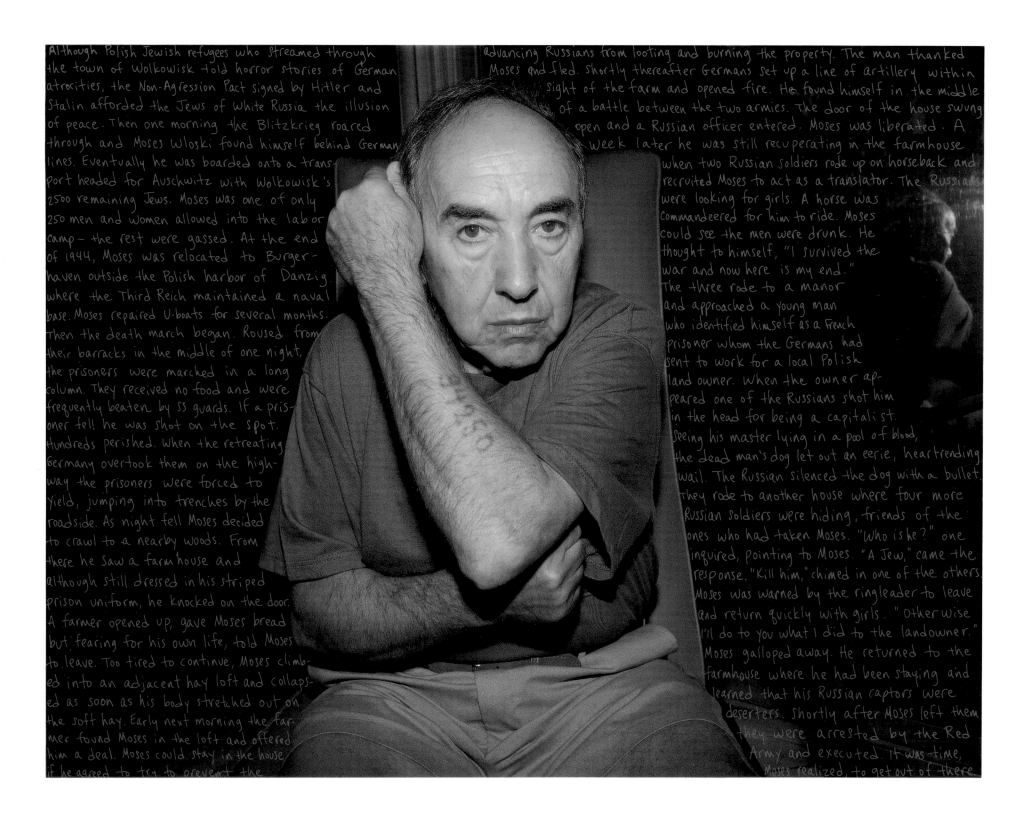

Although Polish Jewish refugees who streamed through the town of Wolkowisk told horror stories of German atrocities, the Non-Agression Pact signed by Hitler and Stalin afforded the Jews of White Russia the illusion of peace. Then one morning the Blitzkrieg roared through and Moses Wloski found himself behind German lines. Eventually he was boarded onto a transport headed for Auschwitz with Wolkowisk's 2500 remaining Jews. Moses was one of only 250 men and women allowed into the labor camp— the rest were gassed. At the end of 1944, Moses was relocated to Burger-haven outside the Polish harbor of Danzig where the Third Reich maintained a naval base. Moses repaired U-boats for several months. Then the death march began. Roused from their barracks in the middle of one night, the prisoners were marched in a long column. They received no food and were frequently beaten by SS guards. If a pris-oner fell he was shot on the spot. Hundreds perished. When the retreating Germany overtook them on the high-way the prisoners were forced to yield, jumping into trenches by the roadside. As night fell Moses decided to crawl to a nearby woods. From there he saw a farmhouse and although still dressed in his striped prison uniform, he knocked on the door. A farmer opened up, gave Moses bread but fearing for his own life, told Moses to leave. Too tired to continue, Moses climb-ed into an adjacent hay loft and collaps-ed as soon as his body stretched out on the soft hay. Early next morning the far-mer found Moses in the loft and offered him a deal. Moses could stay in the house if he agreed to try to prevent the advancing Russians from looting and burning the property. The man thanked Moses and fled. Shortly thereafter Germans set up a line of artillery within sight of the farm and opened fire. He found himself in the middle of a battle between the two armies. The door of the house swung open and a Russian officer entered. Moses was liberated. A week later he was still recuperating in the farmhouse when two Russian soldiers rode up on horseback and recruited Moses to act as a translator. The Russians were looking for girls. A horse was commandeered for him to ride. Moses could see the men were drunk. He thought to himself, "I survived the war and now here is my end." The three rode to a manor and approached a young man who identified himself as a French prisoner whom the Germans had sent to work for a local Polish land owner. When the owner ap-peared one of the Russians shot him in the head for being a capitalist. Seeing his master lying in a pool of blood, the dead man's dog let out an eerie, heartrending wail. The Russian silenced the dog with a bullet. They rode to another house where four more Russian soldiers were hiding, friends of the ones who had taken Moses. "Who is he?" one inquired, pointing to Moses. "A Jew," came the response. "Kill him," chimed in one of the others. Moses was warned by the ringleader to leave and return quickly with girls. "Otherwise I'll do to you what I did to the landowner." Moses galloped away. He returned to the farmhouse where he had been staying and learned that his Russian captors were deserters. Shortly after Moses left them they were arrested by the Red Army and executed. It was time, Moses realized, to get out of there.

(right) *With mother, Vilna, 1933*

(below) *Alone, Vilna, 1940*

LIZA GETTELMAN

born 1922, Vilna, Lithuania

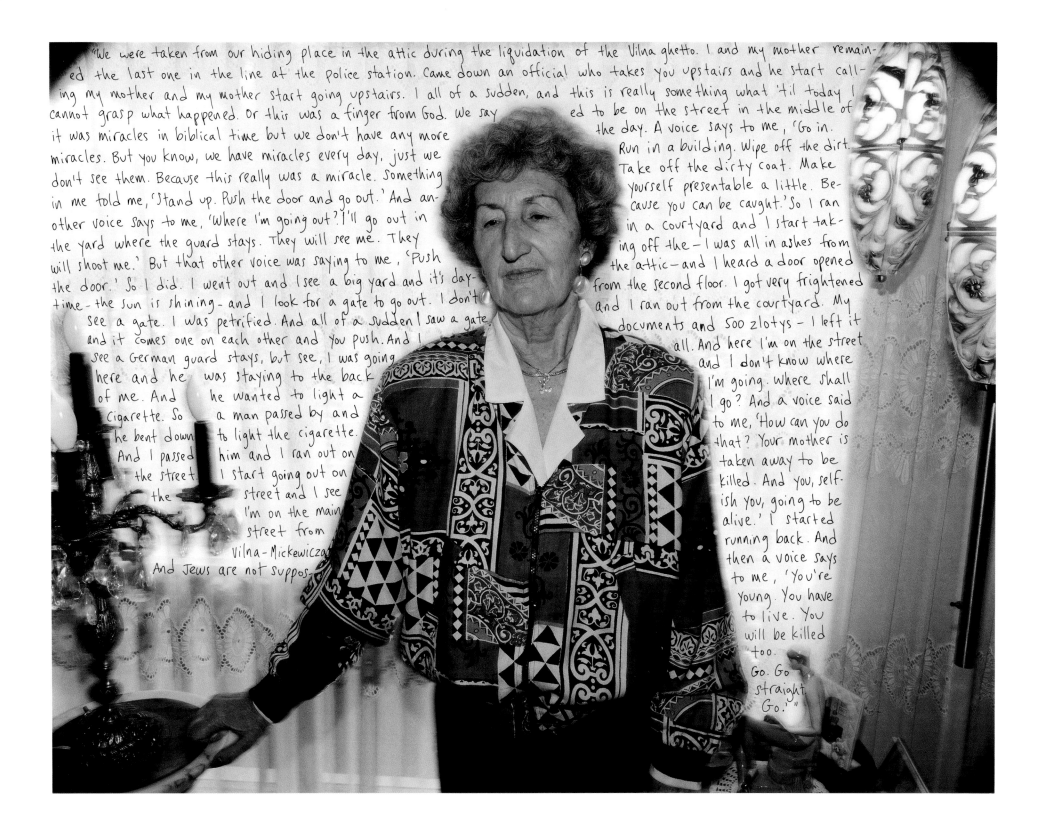

"We were taken from our hiding place in the attic during the liquidation of the Vilna ghetto. I and my mother remained the last one in the line at the police station. Came down an official who takes you upstairs and he start calling my mother and my mother start going upstairs. I all of a sudden, and this is really something what 'til today I cannot grasp what happened. Or this was a finger from God. We say it was miracles in biblical time but we don't have any more miracles. But you know, we have miracles every day, just we don't see them. Because this really was a miracle. Something in me told me, 'Stand up. Push the door and go out.' And another voice says to me, 'Where I'm going out? I'll go out in the yard where the guard stays. They will see me. They will shoot me.' But that other voice was saying to me, 'Push the door.' So I did. I went out and I see a big yard and it's daytime - the sun is shining - and I look for a gate to go out. I don't see a gate. I was petrified. And all of a sudden I saw a gate and it comes one on each other and you push. And I see a German guard stays, but see, I was going here and he was staying to the back of me. And he wanted to light a cigarette. So a man passed by and he bent down to light the cigarette. And I passed him and I ran out on the street. I start going out on the street and I see I'm on the main street from Vilna - Mickewicza. And Jews are not suppos-

ed to be on the street in the middle of the day. A voice says to me, 'Go in. Run in a building. Wipe off the dirt. Take off the dirty coat. Make yourself presentable a little. Because you can be caught.' So I ran in a courtyard and I start taking off the - I was all in ashes from the attic - and I heard a door opened from the second floor. I got very frightened and I ran out from the courtyard. My documents and 500 zlotys - I left it all. And here I'm on the street and I don't know where I'm going. Where shall I go? And a voice said to me, 'How can you do that? Your mother is taken away to be killed. And you, selfish you, going to be alive.' I started running back. And then a voice says to me, 'You're young. You have to live. You will be killed too. Go. Go straight. Go.'"

Taken after liberation in 1946

ARTUR KUPFER

born 1923, Warsaw, Poland

"They needed three young Jews to work for that German outpost in that town. So they selected me and two more men to go there and work for that particular post. It was about 20km away from Nowykorcyn. And we went there and worked for four or five months. We were picked up and brought to that command post. And there they gave us a room where we slept. And we had to do all manual duties, wash their cars, clean their stables, like house boys. They were SS. They were very cruel SS too. We saw some cruelty I'll never forget. Once they found maybe 18-20 Jews hidden in bunkers in the fields. And the Polish police brought them to that outpost. They were in charge of liquidations and not only of Jews—partisans anything that's going politically on. They were a political outpost. They checked all the partisans' movements and political movements—independence movements—but the Jews were the primary job of theirs, to see if there were any Jews moving there or living there. They brought two fully loaded wagons of Jews in that command post. And I saw them and I talked to them and they asked me what's going to happen to them. They knew what's going to happen. I told them, 'I don't know,' although I knew. There was one German. He was of Czech descent, a Bohemian Sudeten German named Hans. He was a terrible killer. All day he went out with his machine gun and he put bottles on a big brick fence and would shoot them all day. If he didn't have anybody to shoot, he shot bottles. He was a vicious killer. He came down and took the Jews with him to the cemetery outside town. Later he brought to me all the clothes. He made them undress—he brought me the clothes—I knew what happened. I should sell them and give him the money and that was my job— to take the clothes to some Polish family there. And I brought him back the money. That was a very traumatic, very tragic experience. Those were families with children. He also took Polish partisans to the fields and shot them. He was like a sergeant in the SS. I had to have his car warmed up if he went out on a raid at night, the car should be ready, clean and serviced, the garage should be open. I was there when he needed me day or night. One night we were sleeping and he slept in a room above us in his quarters and we were downstairs and he had a girlfriend coming in although he was married. I know because I used to send packages to Czechoslovakia to his wife. He had a nurse coming in to spend the night with him and usually at 2 o'clock in the morning or 3 he used to take her back to her hospital post. He usually whistled but this one time we were sleeping soundly so he shot a bullet through the window just a foot above our beds to wake us up to get the car ready."

(right) *Taken before my bar mitzvah, October 15, 1938.*
This was the last bar mitzvah in the synagogue in Stuttgart before it was destroyed on Kristallnacht.

(below) *Ash, Czechoslovakia, May 1945. Frank Levita and I escaped together while on our way to*
a portable gas chamber in the forest around Carlsbad. Frank committed suicide in 1989.

WALTER THALHEIMER

born 1925, Oehringen, Germany

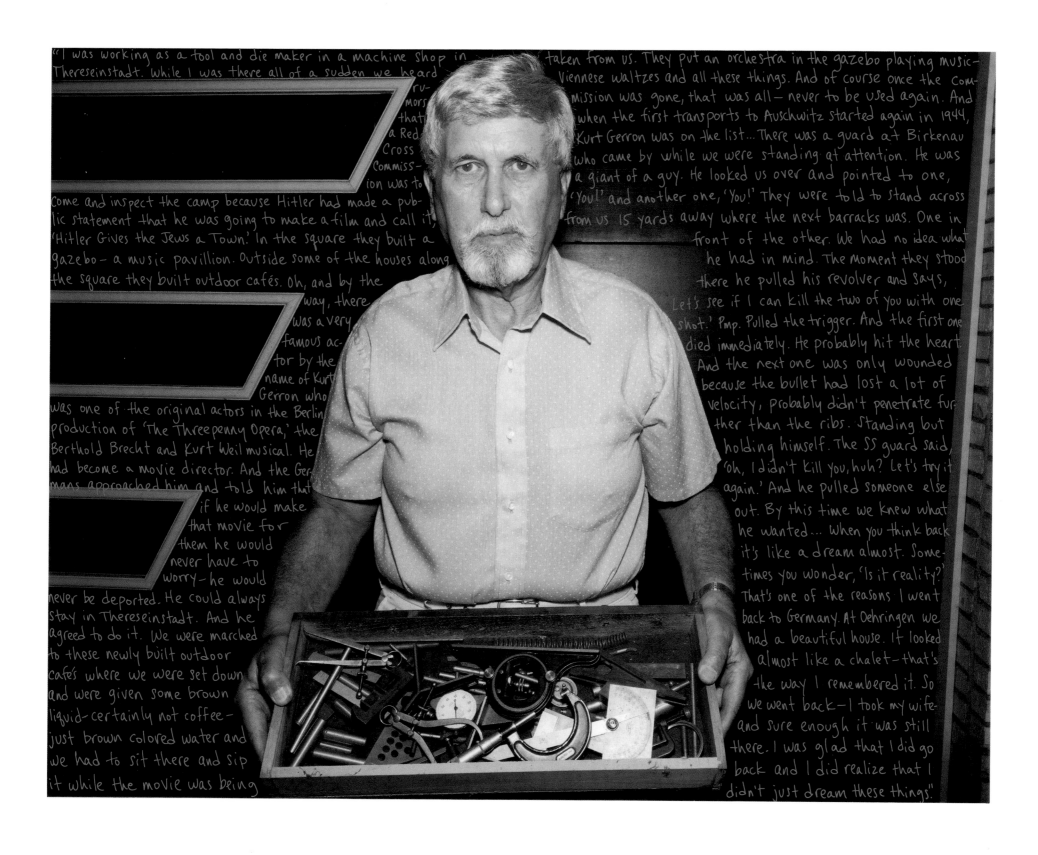

"I was working as a tool and die maker in a machine shop in Thereseinstadt. While I was there all of a sudden we heard rumors that a Red Cross Commission was to come and inspect the camp because Hitler had made a public statement that he was going to make a film and call it, 'Hitler Gives the Jews a Town.' In the square they built a gazebo—a music pavillion. Outside some of the houses along the square they built outdoor cafés. Oh, and by the way, there was a very famous actor by the name of Kurt Gerron who was one of the original actors in the Berlin production of 'The Threepenny Opera,' the Berthold Brecht and Kurt Weil musical. He had become a movie director. And the Germans approached him and told him that if he would make that movie for them he would never have to worry—he would never be deported. He could always stay in Thereseinstadt. And he agreed to do it. We were marched to these newly built outdoor cafés where we were set down and were given some brown liquid—certainly not coffee—just brown colored water and we had to sit there and sip it while the movie was being taken from us. They put an orchestra in the gazebo playing music—Viennese waltzes and all these things. And of course once the commission was gone, that was all—never to be used again. And when the first transports to Auschwitz started again in 1944, Kurt Gerron was on the list...There was a guard at Birkenau who came by while we were standing at attention. He was a giant of a guy. He looked us over and pointed to one, 'You!' and another one, 'You!' They were told to stand across from us 15 yards away where the next barracks was. One in front of the other. We had no idea what he had in mind. The moment they stood there he pulled his revolver and says, 'Let's see if I can kill the two of you with one shot.' Pmp. Pulled the trigger. And the first one died immediately. He probably hit the heart. And the next one was only wounded because the bullet had lost a lot of velocity, probably didn't penetrate further than the ribs. Standing but holding himself. The SS guard said, 'oh, I didn't kill you, huh? Let's try it again.' And he pulled someone else out. By this time we knew what he wanted.... When you think back it's like a dream almost. Sometimes you wonder, 'Is it reality?' That's one of the reasons I went back to Germany. At Oehringen we had a beautiful house. It looked almost like a chalet—that's the way I remembered it. So we went back—I took my wife—and sure enough it was still there. I was glad that I did go back and I did realize that I didn't just dream these things."

1956

MARIA SPITZER

born 1904, Gyor, Hungary

"I, Mrs. Spitzer, b. Maria Hoffmann, was born on February 11, 1904 in Györ. My mother, Mrs. Hoffmann, b. Johanna Waldler, was born in 1874, my father, Mr. Mor Hoffmann, was born in 1872. My brother, Jeno Hoffmann, was born in 1902, the other brother, Sandor Hoffmann, was born on November 8, 1908, my sister, Elza Hoffmann, was born on May 24, 1906, and Ilonka (Mrs. Stern) was born on September 9, 1917. I lived with my parents, brothers and sisters in Györ, Hungary, 34 Bercsenyi, in a house until the March of 1944 when the Germans occupied Györ. The Germans ordered that everyone should wear a Yellow star, and they also put certain regulations on our personal freedom. We could not go out to the streets before 10 in the morning and after 7 in the evening. When we went to work we had to wear the Yellow star on our coats and when the people saw it even the best friend turned his head from us and we were despised very much. Our house became a ghetto, and then we lived in a small one bedroom apartment in the very same house. In our family there were 7 people and later the Germans put 4 more persons into our apartment. We did not have enough place, we had to sleep on the floor. One morning at 5 o'clock the police came and they sent us to the street. There were other people there too, and we were driven to a school where they searched us. A midwife with rubber gloves on her hands examined us if we hid any gold because they were not satisfied with the amount of gold they already had taken from us. We were not allowed to take anything from our apartment with us. From the school we were accompanied to the barracks in Györ where we had to share one small room with 40 people. We slept on the floor, and we did not get enough food. On July 11 we went to the railway station in Györ, and we were loaded into wagons like horses. There were about 80 people in one wagon; the wagon was locked without any food and water. After 4 days we arrived at Auschwitz. By that time several people died in the wagons. When the train arrived we got off and had to stand up in lines. The German, Mengele, stood there in front of the lines, looked at the people, and he waved with his hand if a person should go to the left or to the right. 'Right' meant the working lager and 'left' meant the gas chamber. I was separated from my parents, from my brothers, whom I have never seen since then. I survived with 2 of my sisters. After sending us to the working lager, our hair was cut off, our clothes were taken away and we were locked in an empty barrack. One day Mengele showed up again. We had to walk naked in front of him. He picked out my sisters and we did not see each other since then. I remained in Auschwitz on my own. Every morning at 2 o'clock we had to line up out of the barracks. We did not have appropriate clothes, we were cold and we were starving. We had to stand there until the evening. We could go to our barrack just in the evening. Many of us died from the cold and from starvation. When we went back into the barrack many times we were beaten up very badly. Once I was kicked so much that I feel it in my whole life when I lie on my left side. On August 24 we were taken from Auschwitz to a factory where we produced ammunition. We worked from 6 in the evening to 6 in the morning and we were cold and starving. The factory was in Reichenbach. My eyes went wrong, I have to wear glasses since then. When the liberation was coming the German soldiers drove us for days and nights. We went on foot, it was snowing and very cold. Sometimes we got some sleep in a hay loft. We arrived in Kratzau where I worked in a nearby iron factory... I was liberated on May 8, 1945 in Kratzau. I went home to Györ on foot in the hope that my family would arrive too. Unfortunately the other 6 members of my family were killed so the only person who survived was me."

Prague, 1945

JOSEPH NEUMANN

born 1916, Snina, Slovakia

One of Josef Neumann's first kommandos at Auschwitz was guarding the possessions of Jews who had been taken directly to the gas chambers. Finding a large diamond hidden in the luggage he offered it to his kapo. As a reward Joe was given a few days rest and the option to choose from a variety of work details. He requested a job registering bodies of prisoners who had expired in the barracks. Josef became kapo of the leichenkommando, assembling a six man crew to take corpses to the morgue each day. By the end of 1942 transports of Dutch Jews were arriving and 150 prisoners a day, sometimes as many as 300, died from beatings or committed suicide in the blocks. The leichenkommando was kept quite busy. The following summer an SS medical officer named Mengele, just assigned to the camp, inspected the facilities and asked to see Joe. Mengele had a soft voice and seemed kinder than other Germans. When Josef told him how many prisoners died in the barracks and showed him the battered bodies in the morgue, Mengele was shocked. The young officer punished the kapos who were responsible. Four or five days later Mengele was recalled to Berlin. Upon his return to Auschwitz he selected 2000 prisoners from the barracks to be taken to the gas chambers without delay. He had obviously been instructed about the "Sonderbehandlung," special treatment of the Jews. Joe began to envy the dead because at least their suffering had come to an end. And he learned that he was on a blacklist of prisoners who knew too much to leave Auschwitz alive. In 1944 as the Russian Army swept in from the east, the Germans started to get nervous. An SS guard named Viktor Pastek approached Josef with an escape plan. Pastek was in love with a Jewish girl and wanted Joe to smuggle her out of the camp in his wagon of corpses.

when told the plan would not work, the German offered to take only Joe. Pastek wanted to prove to the girl that he could get someone out of Auschwitz. Joe didn't trust him free him and began making preparations to leave. Suddenly Joe found himself surrounded by SS who had been informed of Pastek's

and refused. Pastek found another Czech prisoner and smuggled him to Prague. Pastek returned to Auschwitz and again tried to enlist Joe in his plan to escape with the girl. By now Joe felt maybe Pastek could

return. Joe and Pastek were incarcerated in Block 11, the camp jail. Pastek was taken first for interrogation. When he was brought back Joe asked the badly bruised man, "Viktor, what did you say?" "I pushed everything on you," the German responded. "Whatever happened is your fault." Josef endured 40 days of torture at the hands of SS officers Brot and Lochmann. When a group of 2000 Polish prisoners from the I.G. Farben works at Auschwitz III were taken to Block 11 to shower before being transported to Sachsenhausen, Joe managed to hide among them. After their train stopped at the camp outside Oranienburg, he learned the Nazis were looking for him. A translator was requested who could speak Polish and German. Joe was picked and ordered to call out "29867," his own number. All the prisoners had to show their tattoos to the Germans while Joe quickly flashed his arm past the Lagerführer who never imagined his translator was actually the fugitive. "Shit," the Nazi exclaimed. "I asked for 2000 prisoners and I have 2000 prisoners. That's it."

JOSEF CSILLAG

born 1913, Szil, Hungary

Josef Csillag was a commissioned officer in the Hungarian Army until 1940 when, like all Jews in the military, he was stripped of his rank and taken to a labor camp. Supervised by Hungarian Fascists, Josef repaired railroad lines for six months in and around Sumeg. Then his outfit was sent to Budapest where they were assigned to the German Army and later marched to the Russian front.

In the Ukraine Josef's unit dug trenches for the SS, who diligently gathered up local civilians suspected of supporting partisan activity. After women, children, and the elderly were lined up by the trenches, the Nazis sprayed them with machine gun fire. Josef watched in horror as their bodies tumbled into mass graves he had dug with his own hands. The SS looted the villagers' homes and burned them to the ground for good measure.

In the Spring of 1943, when Hitler's attack on the Soviet Union had failed, the German Army began to retreat, dragging along its prisoners. In a potato patch in the Ukraine a squadron of Luftwaffe bombers appeared overhead and accidentally rained bombs on the retreating Hungarian Jews. In the field's shallow furrows, Josef planted himself as deeply as possible. A brilliant flash of pain ripped through his body—shrapnel had split open his left hip. The Germans continued their retreat without the Jews. Without food or water, Josef lay in his own blood for three or four days, in agony, unable to walk. A friend finally located Josef and helped him to a first aid station where the largest chunk of metal was removed.

Josef was loaded onto a wagon and taken to a prisoner of war camp in Acbulek, Turkistan, many hundreds of miles from home. Now a prisoner of the Russians, he was still seriously in need of medical attention. A physician named Egedy, himself a Jewish Hungarian POW, found Josef and removed more of the shrapnel that was crippling him. Short on basic medical supplies, Dr. Egedy performed surgery with a pocket knife. There was no anesthesia.

Josef remained in Russian custody until 1946, well after the end of the war. He then returned to his native village of Szil and began looking for traces of his family. He learned that his mother and a younger sister had perished at Auschwitz in 1944, and one brother, Louis, had died near the Don River, deep inside Russia, when he stepped on a land mine.

Josef started to resume his life. He got a job in a state-run butcher shop in nearby Csorna and married Katie, a concentration camp survivor able to understand his loss and the horror of his experiences. For years after the war, bomb fragments continued to work their way out of Josef's body.

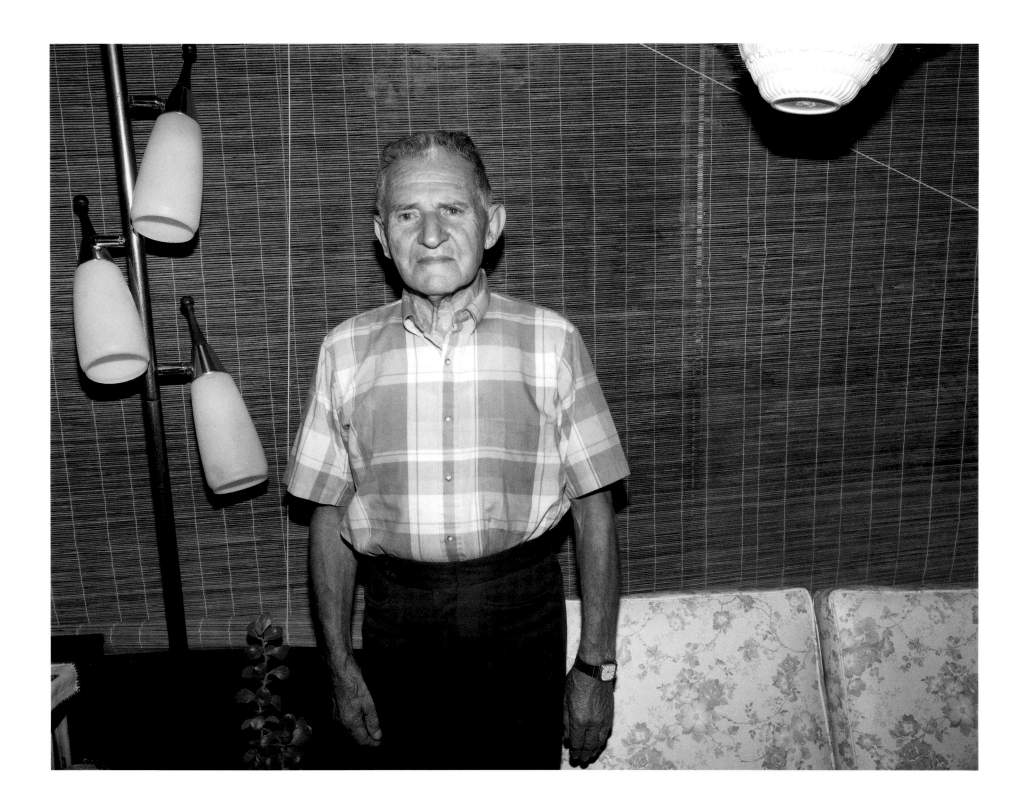

This photograph was taken a day after my natural father took me away from my Polish family.

IDA PALUCH

born 1939, Sosnowiec, Poland

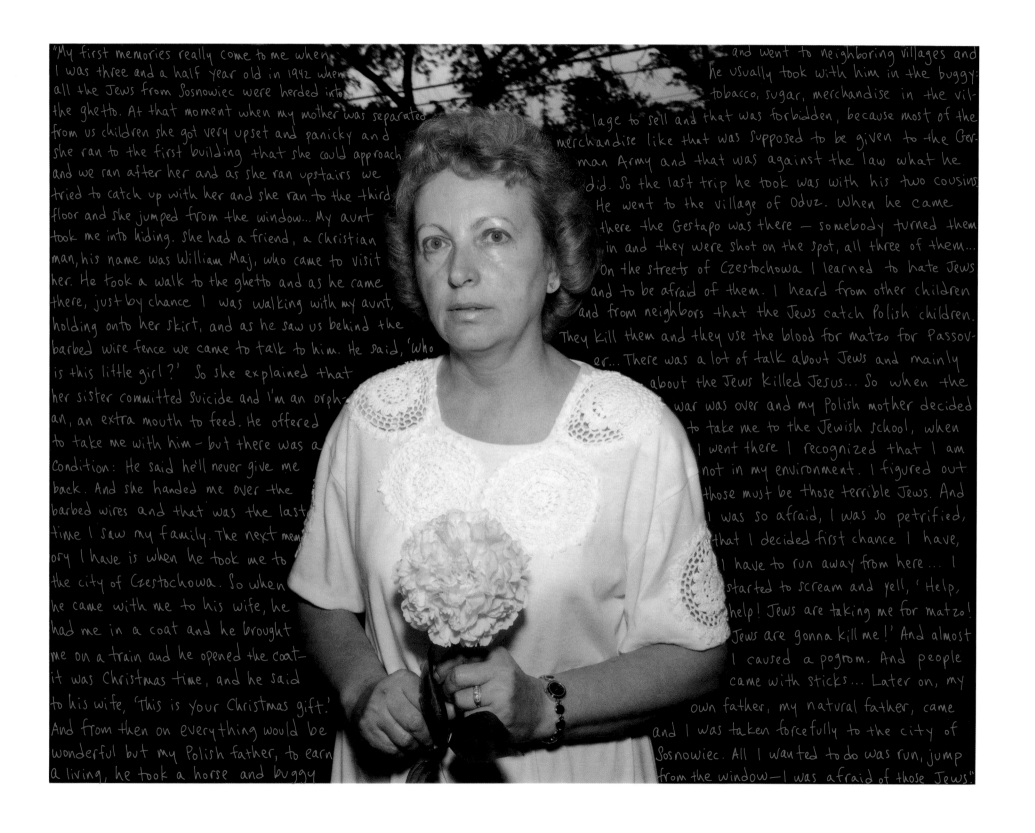

"My first memories really come to me when I was three and a half year old in 1942 when all the Jews from Sosnowiec were herded into the ghetto. At that moment when my mother was separated from us children she got very upset and panicky and she ran to the first building that she could approach and we ran after her and as she ran upstairs we tried to catch up with her and she ran to the third floor and she jumped from the window... My aunt took me into hiding. She had a friend, a christian man, his name was William Maj, who came to visit her. He took a walk to the ghetto and as he came there, just by chance I was walking with my aunt, holding onto her skirt, and as he saw us behind the barbed wire fence we came to talk to him. He said, 'Who is this little girl?' So she explained that her sister committed suicide and I'm an orphan, an extra mouth to feed. He offered to take me with him – but there was a condition: He said he'll never give me back. And she handed me over the barbed wires and that was the last time I saw my family. The next memory I have is when he took me to the city of Czestochowa. So when he came with me to his wife, he had me in a coat and he brought me on a train and he opened the coat- it was Christmas time, and he said to his wife, 'This is your Christmas gift.' And from then on everything would be wonderful but my Polish father, to earn a living, he took a horse and buggy and went to neighboring villages and he usually took with him in the buggy: tobacco, sugar, merchandise in the village to sell and that was forbidden, because most of the merchandise like that was supposed to be given to the German Army and that was against the law what he did. So the last trip he took was with his two cousins. He went to the village of Oduz. When he came there the Gestapo was there – somebody turned them in and they were shot on the spot, all three of them... On the streets of Czestochowa I learned to hate Jews and to be afraid of them. I heard from other children and from neighbors that the Jews catch Polish children. They kill them and they use the blood for matzo for Passover... There was a lot of talk about Jews and mainly about the Jews killed Jesus... So when the war was over and my Polish mother decided to take me to the Jewish school, when I went there I recognized that I am not in my environment. I figured out those must be those terrible Jews. And I was so afraid, I was so petrified, that I decided first chance I have, I have to run away from here... I started to scream and yell, 'Help, help! Jews are taking me for matzo! Jews are gonna kill me!' And almost I caused a pogrom. And people came with sticks... Later on, my own father, my natural father, came and I was taken forcefully to the city of Sosnowiec. All I wanted to do was run, jump from the window—I was afraid of those Jews."

I was liberated on May 5, 1945. The photograph was taken about three months later.

HENRYK WERDINGER

born 1923, Boryslaw, Poland

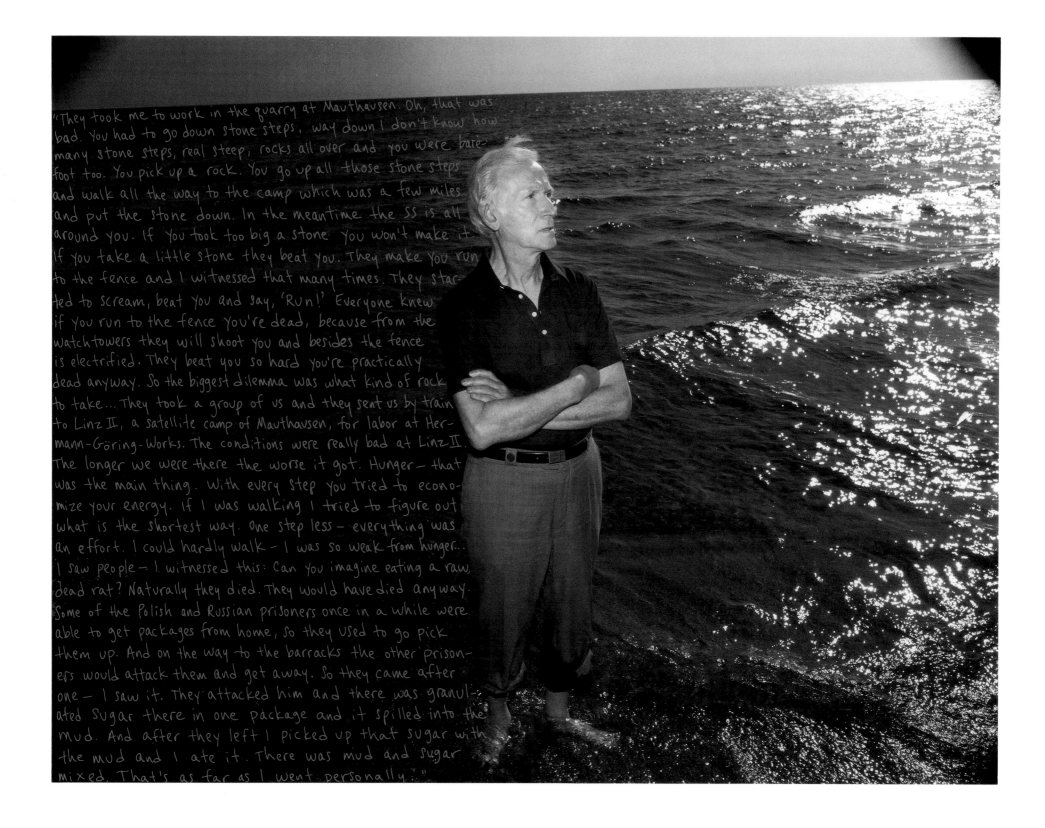

"They took me to work in the quarry at Mauthausen. Oh, that was
bad. You had to go down stone steps, way down I don't know how
many stone steps, real steep, rocks all over and you were bare-
foot too. You pick up a rock. You go up all those stone steps
and walk all the way to the camp which was a few miles
and put the stone down. In the meantime the SS is all
around you. If you took too big a stone you won't make it.
If you take a little stone they beat you. They make you run
to the fence and I witnessed that many times. They star-
ted to scream, beat you and say, 'Run!' Everyone knew
if you run to the fence you're dead, because from the
watchtowers they will shoot you and besides the fence
is electrified. They beat you so hard you're practically
dead anyway. So the biggest dilemma was what kind of rock
to take... They took a group of us and they sent us by train
to Linz II, a satellite camp of Mauthausen, for labor at Her-
mann-Göring-Works. The conditions were really bad at Linz II.
The longer we were there the worse it got. Hunger — that
was the main thing. With every step you tried to econo-
mize your energy. If I was walking I tried to figure out
what is the shortest way. One step less — everything was
an effort. I could hardly walk — I was so weak from hunger...
I saw people — I witnessed this: Can you imagine eating a raw,
dead rat? Naturally they died. They would have died anyway.
Some of the Polish and Russian prisoners once in a while were
able to get packages from home, so they used to go pick
them up. And on the way to the barracks the other prison-
ers would attack them and get away. So they came after
one — I saw it. They attacked him and there was granul-
ated sugar there in one package and it spilled into the
mud. And after they left I picked up that sugar with
the mud and I ate it. There was mud and sugar
mixed. That's as far as I went personally..."

1945

JAKOB SCHWARTZ

born 1928, Sofiendorf, Czechoslovakia

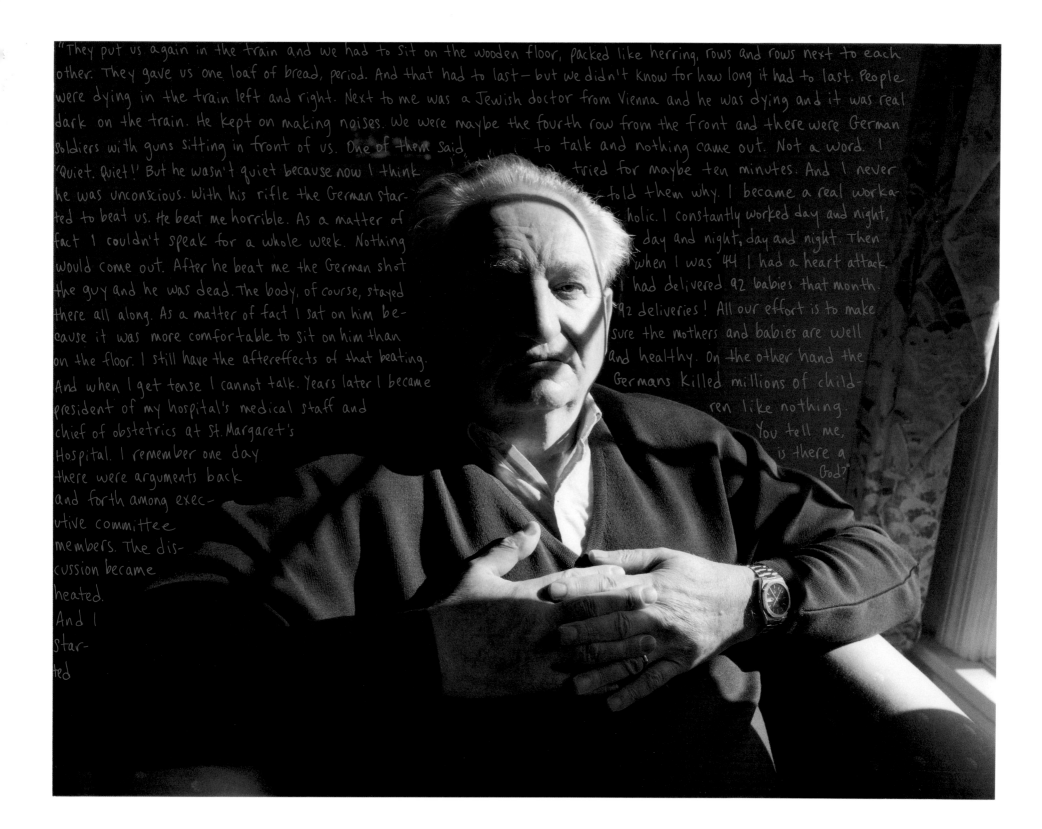

"They put us again in the train and we had to sit on the wooden floor, packed like herring, rows and rows next to each other. They gave us one loaf of bread, period. And that had to last—but we didn't know for how long it had to last. People were dying in the train left and right. Next to me was a Jewish doctor from Vienna and he was dying and it was real dark on the train. He kept on making noises. We were maybe the fourth row from the front and there were German soldiers with guns sitting in front of us. One of them said, "Quiet. Quiet!" But he wasn't quiet because now I think he was unconscious. With his rifle the German started to beat us. He beat me horrible. As a matter of fact I couldn't speak for a whole week. Nothing would come out. After he beat me the German shot the guy and he was dead. The body, of course, stayed there all along. As a matter of fact I sat on him because it was more comfortable to sit on him than on the floor. I still have the aftereffects of that beating. And when I get tense I cannot talk. Years later I became president of my hospital's medical staff and chief of obstetrics at St. Margaret's Hospital. I remember one day there were arguments back and forth among executive committee members. The discussion became heated. And I started

to talk and nothing came out. Not a word. I tried for maybe ten minutes. And I never told them why. I became a real workaholic. I constantly worked day and night, day and night, day and night. Then when I was 44 I had a heart attack. I had delivered 92 babies that month. 92 deliveries! All our effort is to make sure the mothers and babies are well and healthy. On the other hand the Germans killed millions of children like nothing. You tell me, is there a God?"

MEYER BRONICKI

born 1926, Dvorets, White Russia

When the German Army approached Meyer Bronicki's shtetl during the summer of 1941, his older brother, Lippa, fled to Russia and joined the Polish Army in exile. Meyer, fifteen at the time, and the other Jews in the village were forced to wear the yellow star.

In time a labor camp was set up in his village and about 4,000 Jews from surrounding towns were packed in where formerly 500 lived. Meyer was chosen for a work detail to build a barbed wire fence around Dvorets. In late 1942 the Jews were registered and rumors of deportations circulated. Before Christmas, Meyer's father was taken away by the Germans, supposedly to build barracks, and was never seen again.

Rumors of executions became impossible to ignore. Meyer began to excavate a hole under a bed in his home, by hand, carrying dirt out in his pants pockets. When the Germans ordered everyone to gather in the center of town with no more than fifty pounds of belongings, Meyer decided it was time to hide. His mother, a brother and he climbed in to the bunker, positioned a bed above and covered themselves with a sheet of plywood.

Next morning the Germans began a door-to-door search for Jews who failed to appear for deportation. Through a gap in the plywood, Meyer caught a glimpse of jack boots in his room. The village was set on fire that night.

The next day Meyer and his mother walked to the nearby village of Ozierany where they had Gentile friends. Meyer's brother, Shabatai, who was crippled with polio, was left behind until they could safely return for him. Their friends informed the Bronickis that all Jews from the shtetl were killed and buried in a mass grave that the natives of Ozierany had dug. They gave them food, a shovel and ax and recommended that they construct an underground shelter in the woods. On Christmas day, Meyer dug a hole big enough for the two of them at the base of a tree. When he returned the tools, his friends gave them straw for the cave.

The winter of 1942–43 was the coldest in memory, with temperatures dipping to thirty-five degrees below zero. A few feet below the ground, Meyer and his mother remained warm enough to survive. During snowstorms he went out foraging for food. Their friend regularly supplied a loaf of bread that could last up to two weeks. They drank melted snow, and remained in hiding for three months. In the Spring of 1943 a farmer told them that the Germans were defeated at Stalingrad and were retreating. He also mentioned that Jewish partisans were operating in the vicinity.

Meyer and his mother joined a band of over 1,000 partisans living in dugouts underground in wooded encampments. Occasionally their cooking fires would be spotted by German reconnaisance aircraft, which would strafe the camp. Once detected, the partisans immediately packed up and left. Although poorly armed, they waged guerilla warfare against the Germans, ambushing patrols or blowing up bridges and railroad tracks. Their leader, Tovia Bielski, received orders from Moscow that coordinated their attacks with other Polish and Russian resistance fighters and supplied them with passwords, so the different groups would not mistakenly fire upon one another.

The Bronickis remained with the Jewish partisans through the winter. In June 1944 they left the forest to meet the advancing Russian Army on the main road near Novogrudok. Returning to Dvorets they found the town burned to the ground. Only one house was left standing and it was inhabited by non-Jews who agreed to share the residence with them. The Bronickis learned that Shabatai had been shot and killed shortly after they had gone into hiding.

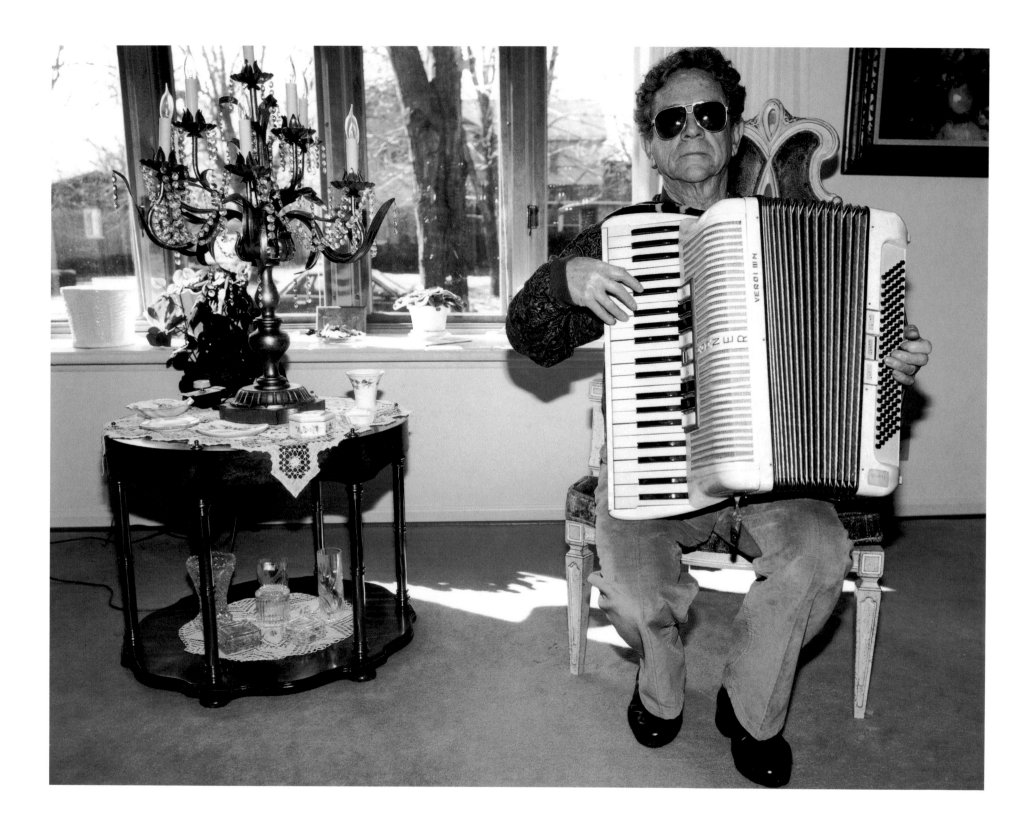

Poland, 1939

TULEK FORSTENZER

born 1912, Tarnow, Poland

"We went to Mauthausen in 1944. In the beginning we didn't see anything. They sent us to carry the stones from one place to another. And from this place to the other, you know, just to keep us busy. We carried the stones all day. There were piles of stone. And then we noticed they had these — not cars — gas wagons. They put fourteen people in one. Once they went into this van they were dead. They used to tell the people they are going to work. They took them for a ride and brought them back dead and they took them over to the ovens. Two of my friends used to work there at the crematoria. So after work I used to go and just watch how they were loading the bodies all day. Pushed a button. The belt went down and turned over. Then up again. It was another part of the camp. My friends were loading the bodies. At that point I was numb. Because I figured they went today, I'll go tomorrow. What do I care? So I just stood there and watched. Nobody really figured to get out of there alive."

(left) *Germany, 1948*

(below) *Germany, 1949*

# HELENA REZNIK

born 1936, Korets, Poland

On a sweltering summer day in Skokie, Helen's daughter, Toby opens the door for me. Helen and Toby are babysitting for Helen's grand-children while her son is going through a divorce. Helen was born Helena Reznik in May 1936 in Korets, Poland. One morning German soldiers appeared in the town and knocked on Helena's front door. Her mother ordered the five year old child to jump out the back window and head for the river. Burdened with Helena's younger sisters, her mother had no chance to escape herself. Like the other captured Jews of Korets, she and Helena's sisters were shot and buried in a mass grave. That night an aunt from a nearby village found out she was alive and sent for her. Her aunt, uncle, their two sons, a mutual cousin and Helena hid in a well-concealed place in the attic. Hearing Germans moving about in the house below, her cousin began to scream. Helena's uncle covered her mouth and suffocated her. Helena was petrif-ied that he was going to kill her too. When it was dark they left their hiding place and escap-ed into the woods. There was precious little to eat and it was now winter. As Helen re-counts these events from her childhood, her grandaughter bounces into the room. "Grandma, can I go to the park?" "Did you eat breakfast?" Helen asks. "Yeah, Fruit Loops." "Listen, grandma's busy. Toby's in charge of you today." The Germans and Ukrainians began combing the woods for Jews. As the soldiers approached their hiding place, Helena fled with her aunt and the two boys. Her uncle was killed by a grenade tossed into the bunker. Helena had no shoes so her aunt wrapped her feet in rags. When the rags got wet and started to freeze, Helena could go no farther. Her aunt abandoned her at the doorstep of a farm they happened upon. Helena was taken inside by a Polish woman who cut off the frozen rags with a razor blade. To this day Helen suffers from frostbite. The family, which consisted of the woman, her husband and two teen-age sons, assumed responsibility for the girl. One day Helena was sent out to the cornfield to round up chickens. While performing her chores she heard screams from the farmhouse and stayed put until dark. As she approached the house Helena saw four severed heads. Her adopted fam-ily had been massacred by Ukrainians. While talk-ing to me, Helen turns her head slowly to see that a grandson is seated next to her staring at her. "You don't want to listen to my story, do you?" she gently inquires. "One day I'll tell you that. Not now. Okay?" Helena ran into another farm inhabited by a Polish coup-le who took the girl in. Fear-ing Ukrainians the Zymbow-skis fled to the woods where they joined a partisan group. Helena went along and stayed with the couple in an underground bunker for a year until their liberation by the Russian Army. Before I leave Helen tells me of a recurrent dream. She is running and men are chasing behind. Desperately she tries to hide and as they close in she wakes up in a sweat. Years ago the dream used to haunt her nightly but now occurs more seldom. It's getting better. Helen decides

(left) *Israel, 1950*

(right) *Israel, August 1961*

(below) *1948*

D. Rosental

DOROTHY BERKOWICZ

born 1923, Stronwicz, Poland

MOISHE BERKOWICZ

born 1926, Stronwicz, Poland

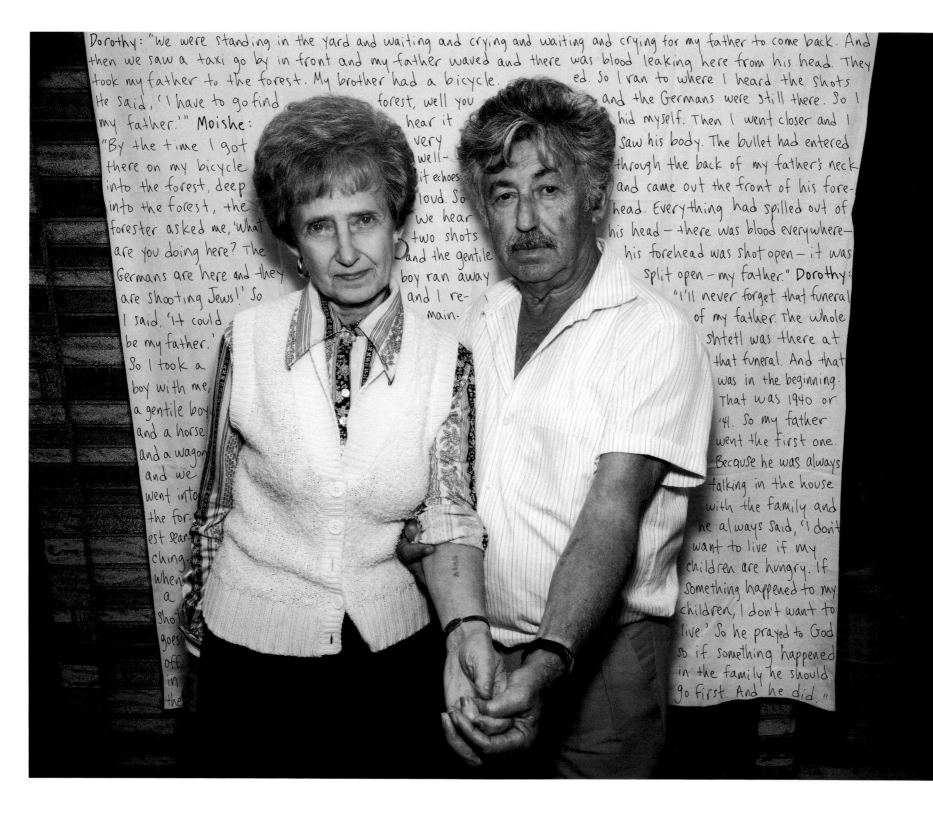

Dorothy: "We were standing in the yard and waiting and crying and waiting and crying for my father to come back. And then we saw a taxi go by in front and my father waved and there was blood leaking here from his head. They took my father to the forest. My brother had a bicycle. forest, well you ed. So I ran to where I heard the shots He said, 'I have to go find hear it and the Germans were still there. So I my father.'" Moishe: very hid myself. Then I went closer and I "By the time I got well- saw his body. The bullet had entered there on my bicycle it echoes through the back of my father's neck into the forest, deep loud. So and came out the front of his fore- into the forest, the we hear head. Everything had spilled out of forester asked me, 'What two shots his head — there was blood everywhere— are you doing here? The and the gentile his forehead was shot open — it was Germans are here and they boy ran away split open — my father." Dorothy: are shooting Jews!' So and I re- "I'll never forget that funeral I said, 'It could main- of my father. The whole be my father.' shtetl was there at So I took a that funeral. And that boy with me, was in the beginning. a gentile boy, That was 1940 or and a horse '41. So my father and a wagon went the first one. and we Because he was always went into talking in the house the for- with the family and est sear- he always said, 'I don't ching. want to live if my When children are hungry. If a something happened to my shot children, I don't want to goes live.' So he prayed to God off so if something happened in in the family he should the go first. And he did."

In a camp near Torino, Italy, 1945

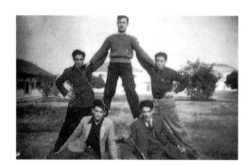

YITZCHAK SUCHOWOLSKI

born 1922, Parczew, Poland

(Also pictured is Esther Levy)

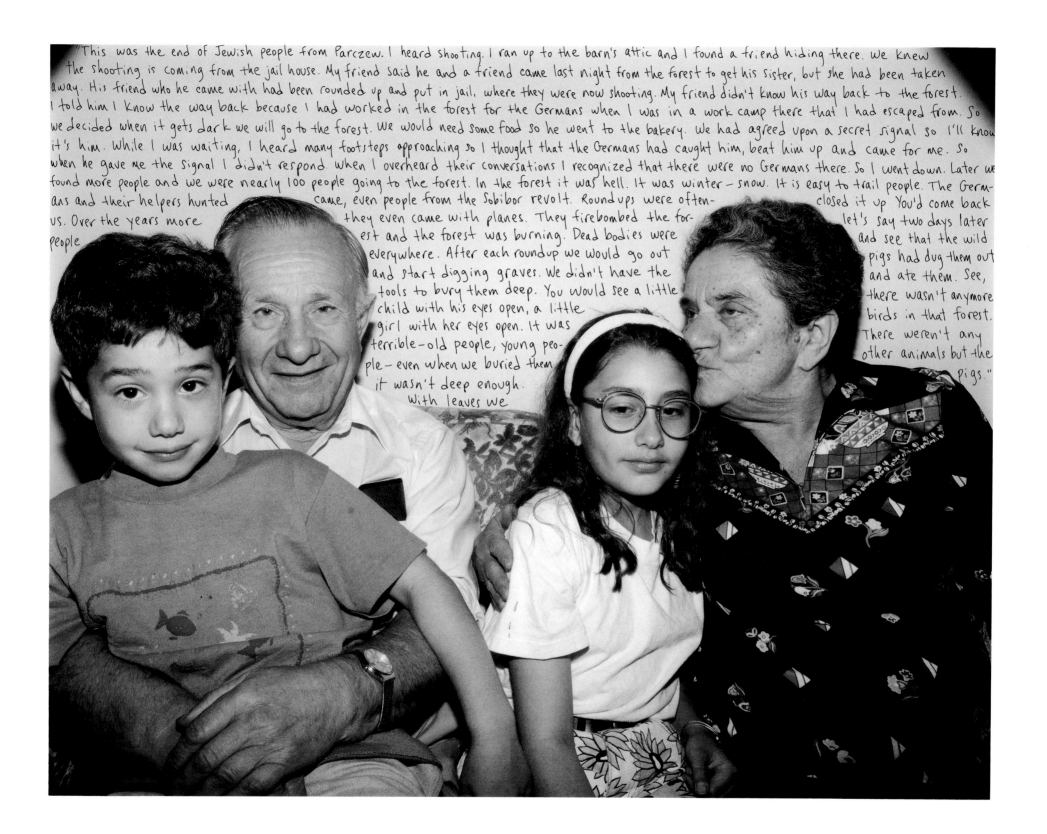

"This was the end of Jewish people from Parczew. I heard shooting. I ran up to the barn's attic and I found a friend hiding there. We knew the shooting is coming from the jail house. My friend said he and a friend came last night from the forest to get his sister, but she had been taken away. His friend who he came with had been rounded up and put in jail, where they were now shooting. My friend didn't know his way back to the forest. I told him I know the way back because I had worked in the forest for the Germans when I was in a work camp there that I had escaped from. So we decided when it gets dark we will go to the forest. We would need some food so he went to the bakery. We had agreed upon a secret signal so I'll know it's him. While I was waiting, I heard many footsteps approaching so I thought that the Germans had caught him, beat him up and came for me. So when he gave me the signal I didn't respond. When I overheard their conversations I recognized that there were no Germans there. So I went down. Later we found more people and we were nearly 100 people going to the forest. In the forest it was hell. It was winter — snow. It is easy to trail people. The Germans and their helpers hunted us. Over the years more people came, even people from the Sobibor revolt. Round ups were often — they even came with planes. They firebombed the forest and the forest was burning. Dead bodies were everywhere. After each roundup we would go out and start digging graves. We didn't have the tools to bury them deep. You would see a little child with his eyes open, a little girl with her eyes open. It was terrible — old people, young people — even when we buried them it wasn't deep enough. With leaves we closed it up. You'd come back let's say two days later and see that the wild pigs had dug them out and ate them. See, there wasn't anymore birds in that forest. There weren't any other animals but the pigs."

GIZELLA SALOMONOVITZ

born 1920, Starina, Slovakia

Thousands of Jews had fled Hungary using passports issued by Raoul Wallenberg, the Swedish Consul in Budapest. By the time Gizella Salamonovitz (Gita) managed to secure one of these prized *schutzbriefen*, however, the papers afforded little protection. She was forced to move into one of Budapest's Jewish ghetto houses. Gita stayed in a three-room apartment with an older Jewish couple and their daughter-in-law, Elizabeth, who had a five-year-old son.

One day Elizabeth was informed that her sister had been arrested, but Elizabeth's two-year-old niece was left behind in the apartment all alone. Ignoring the law against Jews being allowed on the streets, Elizabeth retrieved the girl. During one of Budapest's frequent air raids, Gita, avoiding bombs and police, worked her way to a Jewish agency to seek help for the children and was given an address on the other side of the Danube. After another air raid, she and Elizabeth took the children to the address, which was a monastery. Without saying a word, the nuns took the children in. Two days later, near the end of November 1944, the Arrow Cross—a Hungarian fascist group—arrested Gita and Elizabeth at their apartment and marched them to a brickyard, where the women were detained with other Jews awaiting deportation. By this time the Russian Army was at the outskirts of town. The two friends were put on the last train to leave Budapest before its liberation.

The train stopped at Ravensbrück, a camp north of Berlin. Gita remembered: "We stopped in the middle of the night. The doors opened. The screaming, 'Get out, Get out! *Rauß, rauß, rauß!*' was impossible. We looked out and all I could see was lights in our faces. Dogs and uniforms and in the distance I saw a chimney with a fire. I knew what that was. I saw people in striped uniforms running around being beaten—just unbelievable chaos for the mind to see that, all at once from the darkness into that bright light and to get in all this. I turned to my friend Elizabeth and I said, 'Oh my God. We are in Dante's Inferno.'"

Gita remained at Ravensbrück for a month. In January she was transported to Penig where she worked on an assembly line making airplane parts. On April 10, 1945 the Allies drew close. "The Nazis marched us for two days. Then they put us on trucks for two days going around. The idea was, I think, to get us to a camp where they had gas chambers to destroy us. After five days of all this the trucks were stopped by the Red Cross, and we finally got some food—after five days. They took us off the trucks and started walking with us again. At night we went into a forest and we lay down for the night. In the morning when I got up the SS had disappeared. We were alone. And so at that point I and nine girls started going by foot. We really didn't know which way we are going. But I thought if I go east I'll get to Czechoslovakia, and I am going home."

Liberation was actually the most painful time of all for Gita. She was forced to accept the fact that her entire family had been murdered; one sister died just two days after her liberation at Bergen-Belsen. However, Gita did learn that at least the two children she and Elizabeth had smuggled to the monastery in Budapest survived the war.

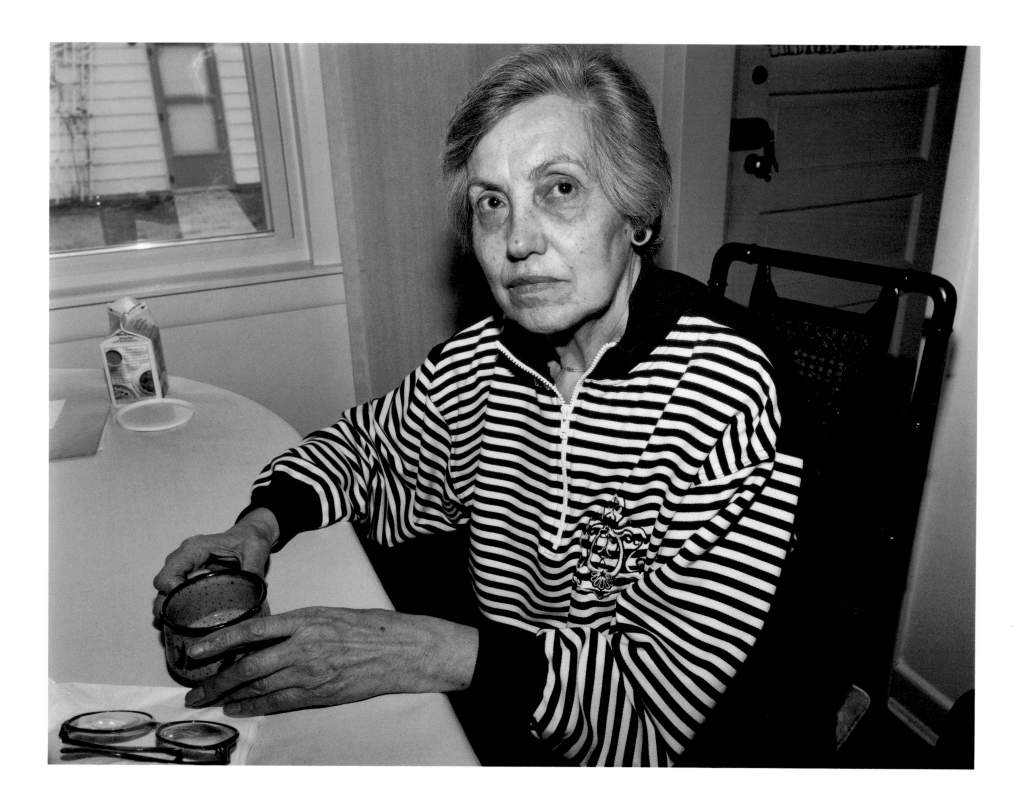

This was our engagement picture. Farad, 1947

(Also pictured is Josef Csillag)

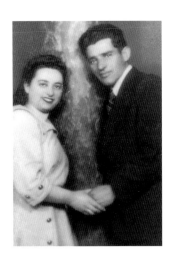

KATIE STEINER

born 1925, Farad, Hungary

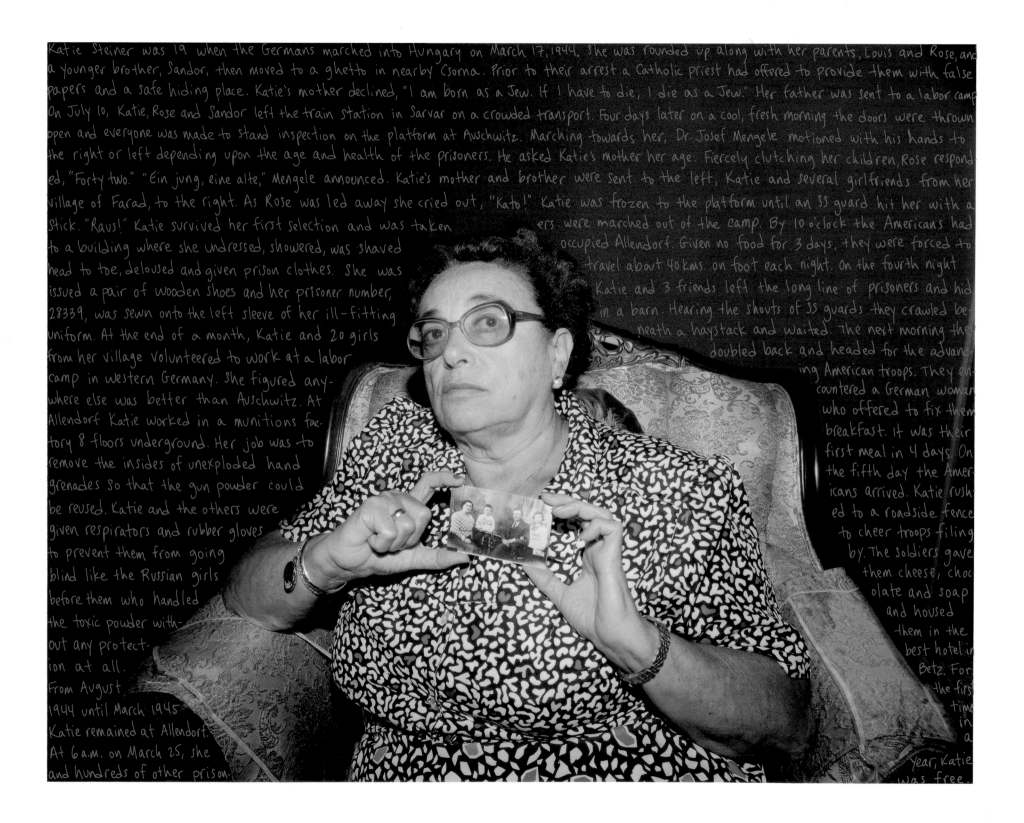

Katie Steiner was 19 when the Germans marched into Hungary on March 17, 1944. She was rounded up along with her parents, Louis and Rose, and a younger brother, Sandor, then moved to a ghetto in nearby Csorna. Prior to their arrest a Catholic priest had offered to provide them with false papers and a safe hiding place. Katie's mother declined, "I am born as a Jew. If I have to die, I die as a Jew." Her father was sent to a labor camp. On July 10, Katie, Rose and Sandor left the train station in Sarvar on a crowded transport. Four days later on a cool, fresh morning the doors were thrown open and everyone was made to stand inspection on the platform at Auschwitz. Marching towards her, Dr. Josef Mengele motioned with his hands to the right or left depending upon the age and health of the prisoners. He asked Katie's mother her age. Fiercely clutching her children, Rose responded, "Forty two." "Ein jung, eine alte," Mengele announced. Katie's mother and brother were sent to the left, Katie and several girlfriends from her village of Farad, to the right. As Rose was led away she cried out, "Kato!" Katie was frozen to the platform until an SS guard hit her with a stick. "Raus!" Katie survived her first selection and was taken to a building where she undressed, showered, was shaved head to toe, deloused and given prison clothes. She was issued a pair of wooden shoes and her prisoner number, 28339, was sewn onto the left sleeve of her ill-fitting uniform. At the end of a month, Katie and 20 girls from her village volunteered to work at a labor camp in western Germany. She figured anywhere else was better than Auschwitz. At Allendorf Katie worked in a munitions factory 8 floors underground. Her job was to remove the insides of unexploded hand grenades so that the gun powder could be reused. Katie and the others were given respirators and rubber gloves to prevent them from going blind like the Russian girls before them who handled the toxic powder without any protection at all. From August 1944 until March 1945 Katie remained at Allendorf. At 6 a.m. on March 25, she and hundreds of other prison-ers were marched out of the camp. By 10 o'clock the Americans had occupied Allendorf. Given no food for 3 days, they were forced to travel about 40 kms. on foot each night. On the fourth night Katie and 3 friends left the long line of prisoners and hid in a barn. Hearing the shouts of SS guards they crawled beneath a haystack and waited. The next morning they doubled back and headed for the advancing American troops. They encountered a German woman who offered to fix them breakfast. It was their first meal in 4 days. On the fifth day the Americans arrived. Katie rushed to a roadside fence to cheer troops filing by. The soldiers gave them cheese, chocolate and soap and housed them in the best hotel in Betz. For the first time in a year, Katie was free.

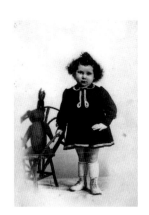

(right) *The picture with the teddy bear is from early 1940.*
My mother sent it to my father while he was in the French Army in Algeria.
(below) *1947, when I was about ten years old*

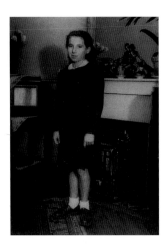

ADELE LAZNOWSKI

born 1937, Paris, France

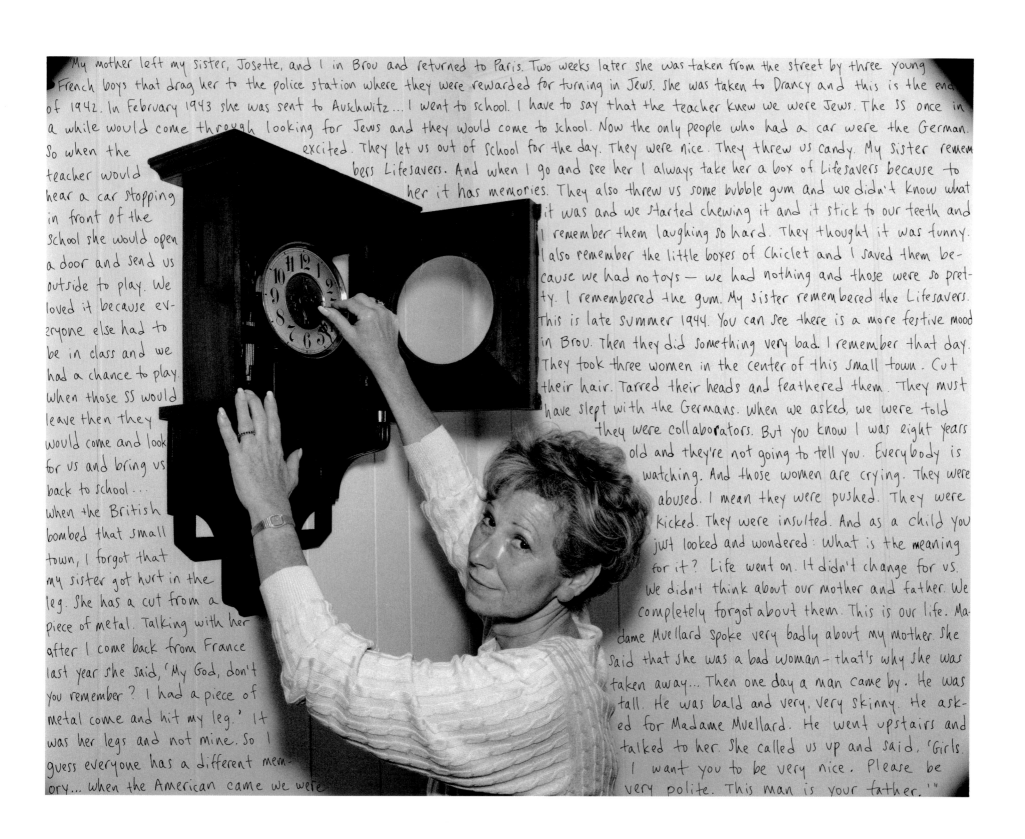

"My mother left my sister, Josette, and I in Brou and returned to Paris. Two weeks later she was taken from the street by three young French boys that drag her to the police station where they were rewarded for turning in Jews. she was taken to Drancy and this is the end of 1942. In February 1943 she was sent to Auschwitz... I went to school. I have to say that the teacher knew we were Jews. The SS once in a while would come through looking for Jews and they would come to school. Now the only people who had a car were the German. So when the teacher would hear a car stopping in front of the school she would open a door and send us outside to play. We loved it because everyone else had to be in class and we had a chance to play. when those SS would leave then they would come and look for us and bring us back to school... when the British bombed that small town, I forgot that my sister got hurt in the leg. She has a cut from a piece of metal. Talking with her after I come back from France last year she said, 'My God, don't you remember? I had a piece of metal come and hit my leg.' It was her legs and not mine. So I guess everyone has a different memory... when the American came we were excited. They let us out of school for the day. They were nice. They threw us candy. My sister remembers Lifesavers. And when I go and see her I always take her a box of Lifesavers because to her it has memories. They also threw us some bubble gum and we didn't know what it was and we started chewing it and it stick to our teeth and I remember them laughing so hard. They thought it was funny. I also remember the little boxes of Chiclet and I saved them because we had no toys — we had nothing and those were so pretty. I remembered the gum. My sister remembered the Lifesavers. This is late summer 1944. You can see there is a more festive mood in Brou. Then they did something very bad. I remember that day. They took three women in the center of this small town. Cut their hair. Tarred their heads and feathered them. They must have slept with the Germans. when we asked, we were told they were collaborators. But you know I was eight years old and they're not going to tell you. Everybody is watching. And those women are crying. They were abused. I mean they were pushed. They were kicked. They were insulted. And as a child you just looked and wondered: What is the meaning for it? Life went on. It didn't change for us. We didn't think about our mother and father. We completely forgot about them. This is our life. Madame Muellard spoke very badly about my mother. She said that she was a bad woman— that's why she was taken away... Then one day a man came by. He was tall. He was bald and very, very skinny. He asked for Madame Muellard. He went upstairs and talked to her. She called us up and said, 'Girls, I want you to be very nice. Please be very polite. This man is your father.'"

This picture was taken in March 1944. At that time I was stationed at Avon Park, Florida, where we were training as a B-17 flight crew before going to Europe to fly our missions.

HEINZ KATZ

born 1920, Hamburg, Germany

Even though he was only 13 when Hitler was appointed Chancellor of the Reichstag in 1933, Heinz Katz knew trouble was brewing in the peaceful village of Homberg when his non-Jewish friends began singing this song while marching at school: "Wenn das Juden blut von messer spritzt geht es zmeimal als gut." (When Jewish blood spurts from a knife, it is twice as good.") After all, these were not hard-line Nazi fanatics, but kids he grew up playing with, whose birthday parties he'd been to. Heinz's father, Robert, decided to send his son to America through a special relief program of the German Jewish Children's Committee. In 1934, 154 kids from Nazi Germany with no family ties to the United States, were selected for foster homes in the U.S. Robert was hoping that Hitler would only last as long as previous chancellors of the Weimar Republic, none of whom had served longer than a year since the depression began. He expected Heinz would soon return home to Germany when the insanity that was National Socialism blew over. Robert had been among Homberg's leading citizens, a World War I hero and the first soldier in the town's history to be awarded the Iron Cross. The Katz family had lived in the vicinity for hundreds of years. Robert never dreamed that things would deteriorate to the point that he would be assaulted on Kristallnacht and incarcerated at Buchenwald. Seven years after coming to the US and 2 years after learning of his father's death as a result of illness contracted in the concentration camp, Heinz joined the American Army. He wanted to fight the Nazis. He was sent to gunnery school and in 1944 joined the 8th Air Force Squadron in England. A few days after D-Day he was aloft as the ball turret gunner on a B-17 Flying Fortress. Heinz flew 25 bombing missions, an entire tour of duty, then volunteered for another 10 flights. He received particular satisfaction from the missions over Germany where his B-17 bombed railroad tracks, factories and munition dumps in major cities. Like his father, Heinz became a decorated combat veteran, earning the Distinguished Flying Cross. It took years of correspondence and several visits to his birthplace in Germany before Heinz was able to locate his father's final resting place.

Berlin, 1938

LISELOTTE KLOPSTOCK

born 1931, Berlin, Germany

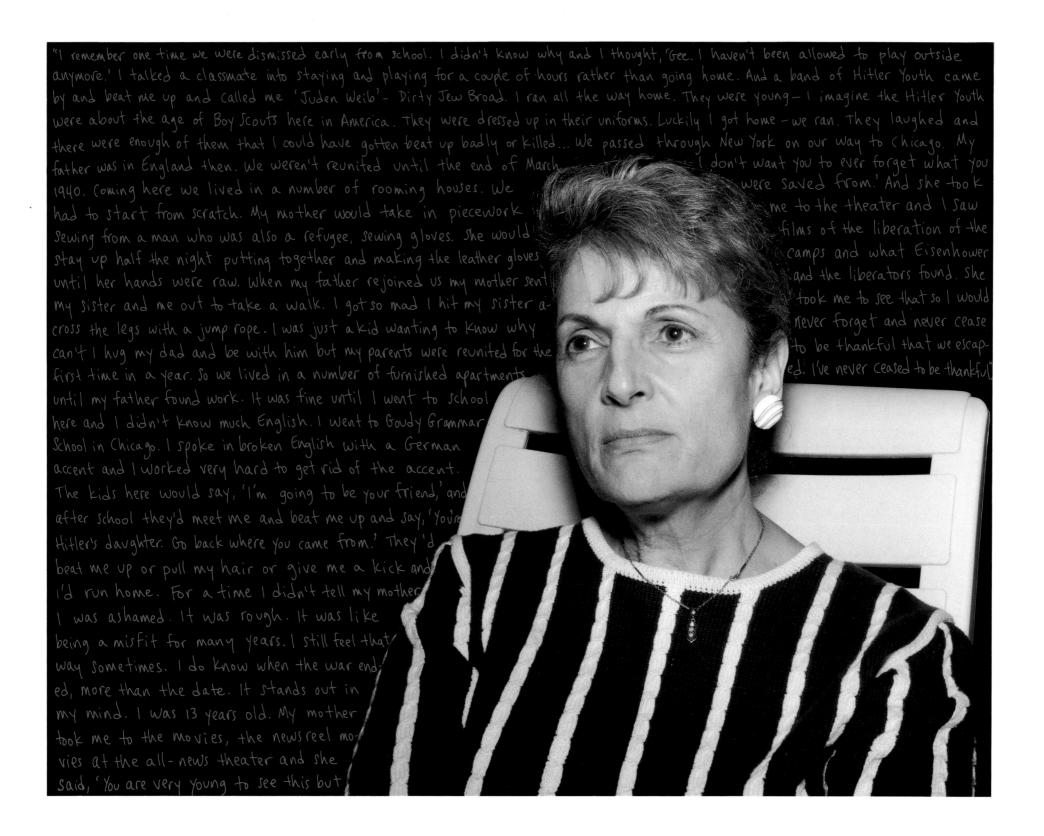

"I remember one time we were dismissed early from school. I didn't know why and I thought, 'Gee. I haven't been allowed to play outside anymore.' I talked a classmate into staying and playing for a couple of hours rather than going home. And a band of Hitler Youth came by and beat me up and called me 'Juden Weib'- Dirty Jew Broad. I ran all the way home. They were young— I imagine the Hitler Youth were about the age of Boy Scouts here in America. They were dressed up in their uniforms. Luckily I got home - we ran. They laughed and there were enough of them that I could have gotten beat up badly or killed... We passed through New York on our way to Chicago. My father was in England then. We weren't reunited until the end of March [...] I don't want you to ever forget what you 1940. Coming here we lived in a number of rooming houses. We [...] were saved from.' And she took had to start from scratch. My mother would take in piecework [...] me to the theater and I saw sewing from a man who was also a refugee, sewing gloves. She would [...] films of the liberation of the stay up half the night putting together and making the leather gloves [...] camps and what Eisenhower until her hands were raw. When my father rejoined us my mother sent [...] and the liberators found. She my sister and me out to take a walk. I got so mad I hit my sister a- [...] took me to see that so I would cross the legs with a jump rope. I was just a kid wanting to know why [...] never forget and never cease can't I hug my dad and be with him but my parents were reunited for the [...] to be thankful that we escap- first time in a year. So we lived in a number of furnished apartments [...] ed. I've never ceased to be thankful' until my father found work. It was fine until I went to school here and I didn't know much English. I went to Goudy Grammar School in Chicago. I spoke in broken English with a German accent and I worked very hard to get rid of the accent. The kids here would say, 'I'm going to be your friend,' and after school they'd meet me and beat me up and say, 'You're Hitler's daughter. Go back where you came from.' They'd beat me up or pull my hair or give me a kick and I'd run home. For a time I didn't tell my mother. I was ashamed. It was rough. It was like being a misfit for many years. I still feel that way sometimes. I do know when the war end- ed, more than the date. It stands out in my mind. I was 13 years old. My mother took me to the movies, the newsreel mo- vies at the all-news theater and she said, 'You are very young to see this but

October 1945, three years old. Sometime after returning from Theresienstadt.

GITTEL JASKULSKI

born 1942, Berlin, Germany

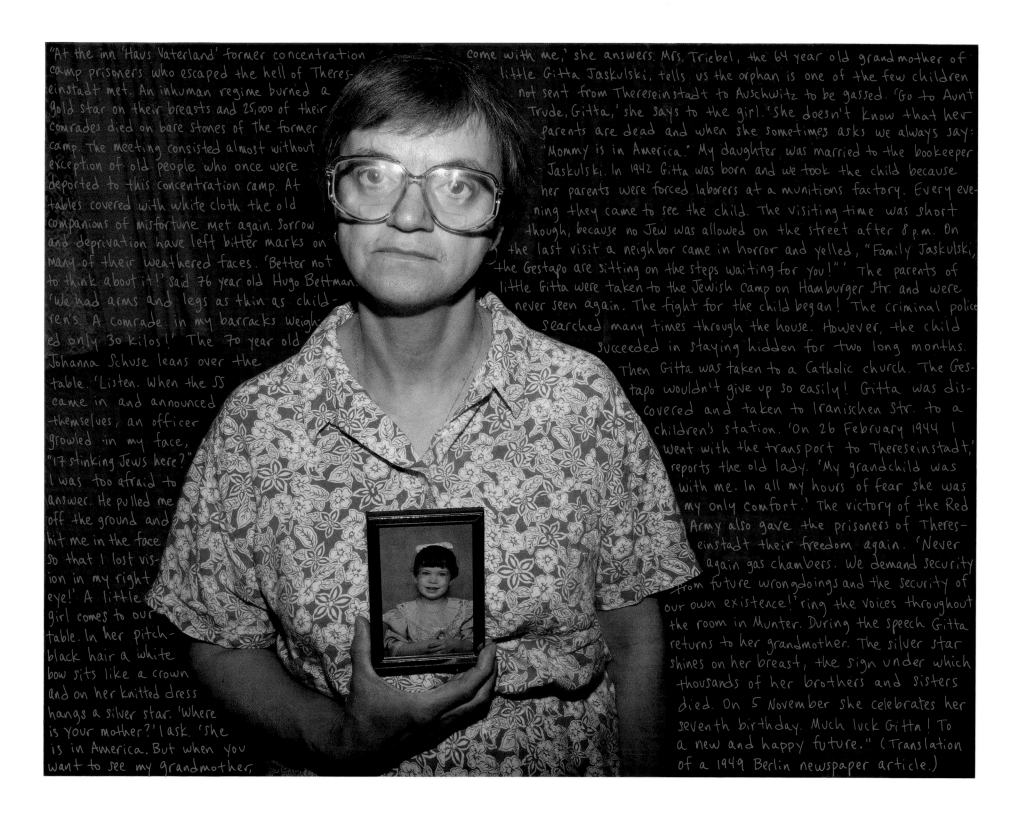

"At the inn 'Haus Vaterland' former concentration camp prisoners who escaped the hell of Theresienstadt met. An inhuman regime burned a gold star on their breasts and 25,000 of their comrades died on bare stones of the former camp. The meeting consisted almost without exception of old people who once were deported to this concentration camp. At tables covered with white cloth the old companions of misfortune met again. Sorrow and deprivation have left bitter marks on many of their weathered faces. 'Better not to think about it!' said 76 year old Hugo Bettman. 'We had arms and legs as thin as children's. A comrade in my barracks weighed only 30 kilos!' The 70 year old Johanna Schuse leans over the table. 'Listen. When the SS came in and announced themselves, an officer growled in my face, "17 stinking Jews here?" I was too afraid to answer. He pulled me off the ground and hit me in the face so that I lost vision in my right eye!' A little girl comes to our table. In her pitch-black hair a white bow sits like a crown and on her knitted dress hangs a silver star. 'Where is your mother?' I ask. 'She is in America. But when you want to see my grandmother, come with me,' she answers. Mrs. Triebel, the 64 year old grandmother of little Gitta Jaskulski, tells us the orphan is one of the few children not sent from Thereseinstadt to Auschwitz to be gassed. 'Go to Aunt Trude, Gitta,' she says to the girl. 'She doesn't know that her parents are dead and when she sometimes asks we always say: "Mommy is in America." My daughter was married to the bookeeper Jaskulski. In 1942 Gitta was born and we took the child because her parents were forced laborers at a munitions factory. Every evening they came to see the child. The visiting time was short though, because no Jew was allowed on the street after 8 p.m. On the last visit a neighbor came in horror and yelled, "Family Jaskulski, the Gestapo are sitting on the steps waiting for you!"' The parents of little Gitta were taken to the Jewish camp on Hamburger Str. and were never seen again. The fight for the child began! The criminal police searched many times through the house. However, the child succeeded in staying hidden for two long months. Then Gitta was taken to a Catholic church. The Gestapo wouldn't give up so easily! Gitta was discovered and taken to Iranischen Str. to a children's station. 'On 26 February 1944 I went with the transport to Thereseinstadt,' reports the old lady. 'My grandchild was with me. In all my hours of fear she was my only comfort.' The victory of the Red Army also gave the prisoners of Thereseinstadt their freedom again. 'Never again gas chambers. We demand security from future wrongdoings and the security of our own existence!' ring the voices throughout the room in Munter. During the speech Gitta returns to her grandmother. The silver star shines on her breast, the sign under which thousands of her brothers and sisters died. On 5 November she celebrates her seventh birthday. Much luck Gitta! To a new and happy future." (Translation of a 1949 Berlin newspaper article.)

HÉLÈNE PERSITZ

born 1912, Daugavpils, Russia

"Things that happened to me personally were in the way of miracles. Sometime in June, I believe, '44, during the *appel* (roll call) at Auschwitz, we were standing in the evening and it lasted and lasted. And suddenly there was a rumor—somebody had escaped. The Germans called it *geflitzt*. And finally it turned out that when the *appel* was called off, in the end we heard that a woman called Mala had escaped from the women's camp together with a Polish fellow from the men's camp. Now Mala was a *personage* in the women's camp about whom everybody had heard, if not known her. Mala was a young Polish Jewish woman who lived in Belgium and had been arrested there and sent to Auschwitz. Somehow she had become in the camp what they called an interpreter *(ein Dolmetscher)*. Now an interpreter inside the camp was somebody among the 'aristocrats' of the camp. It meant, of course, working under the orders of the German administration, but being an interpreter gave Mala all sorts of privileges, not only better conditions of life, better clothes, better rations, but also a certain prestige, which allowed her more freedom of movement inside the camp and gave the possibility of helping other prisoners by providing more food, finding less strenuous *Kommando* work, etc. She had the reputation of a saint among her co-prisoners.

"Mala had escaped together with a man from the men's camp and a few days later we knew that they had been caught. Mala was hanged in the presence of all the prisoners. It was said later that at the very last moment she had tried to cut her wrists, or she spit in the face of the hangman, or shouted some violent words before she died. Then all the other women who had held posts like interpreters were deprived of their privileges and jobs and taken to a disciplinary block. So that suddenly the Germans needed more interpreters.

"In my barrack, the *blockova* (chief of block) was like most of the *blockovas* in the camp, a Slovak girl who was sturdy and had already lived in the camp for two years or more. She had the authority over the hundred or more inmates of the block, but also the privilege of a room for herself and better conditions in general.

"One day she called me and said, 'Look, you know several languages, don't you? And the Germans need another interpreter for the camp. Why don't you go and ask the *Arbeitsführer* (chief of the work force), maybe you can get this job.'

"'Yes, why not? I can try.' So in the evening after the return of my *Kommando*, I made myself as presentable as possible and went to see the *Arbeitsführer*. He was in a small office near the camp entrance, talking to an SS woman. The rule was that I had to stand *en garde à vous* and say, 'Prisoner # so and so.' 'What do you want,' he said. I replied, 'I heard maybe you need another

interpreter. I know French, Russian, Polish, Czech…' This is what I remember: the man looked at me, turned to the woman in uniform and said, 'She's not going to be more stupid than another one. Let's take her.' And this is why I'm still here."

I have found a snapshot of me, taken in Nice during the summer of 1942. This was a period when my husband and I lived a relatively 'normal' life. My husband was an architect, but had accepted a job as a draftsman. We were not aware of immediate danger, because Nice was in the non-occupied zone ('zone libre'), and our main problem was the shortage of food supplies in Nice. This rather 'happy' life ended suddenly when in the Autumn of 1943 the German occupation was extended to the entire territory and the Jews either fled or went 'underground.'

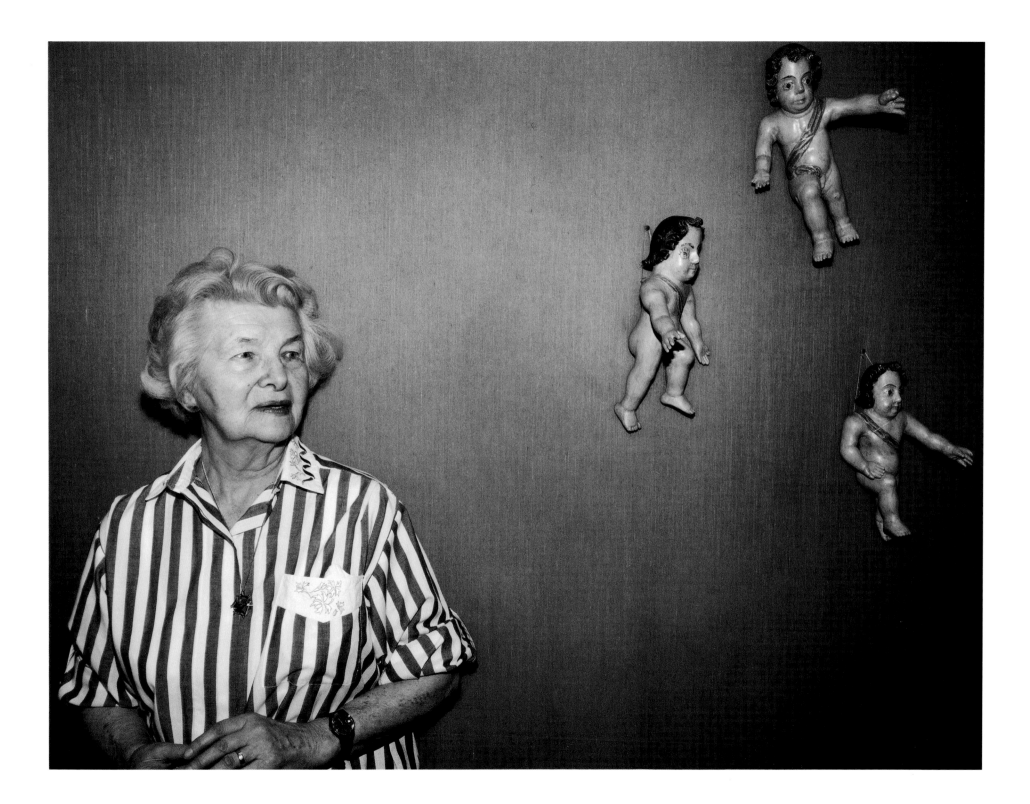

Alice Redlich and myself after our engagement in 1947 in Germany.
Alice came to Bergen-Belsen in 1946 from Germany with a Jewish relief organization
and worked with the liberated and newborn children in Belsen.

HANS FINKE

born 1920, Berlin, Germany

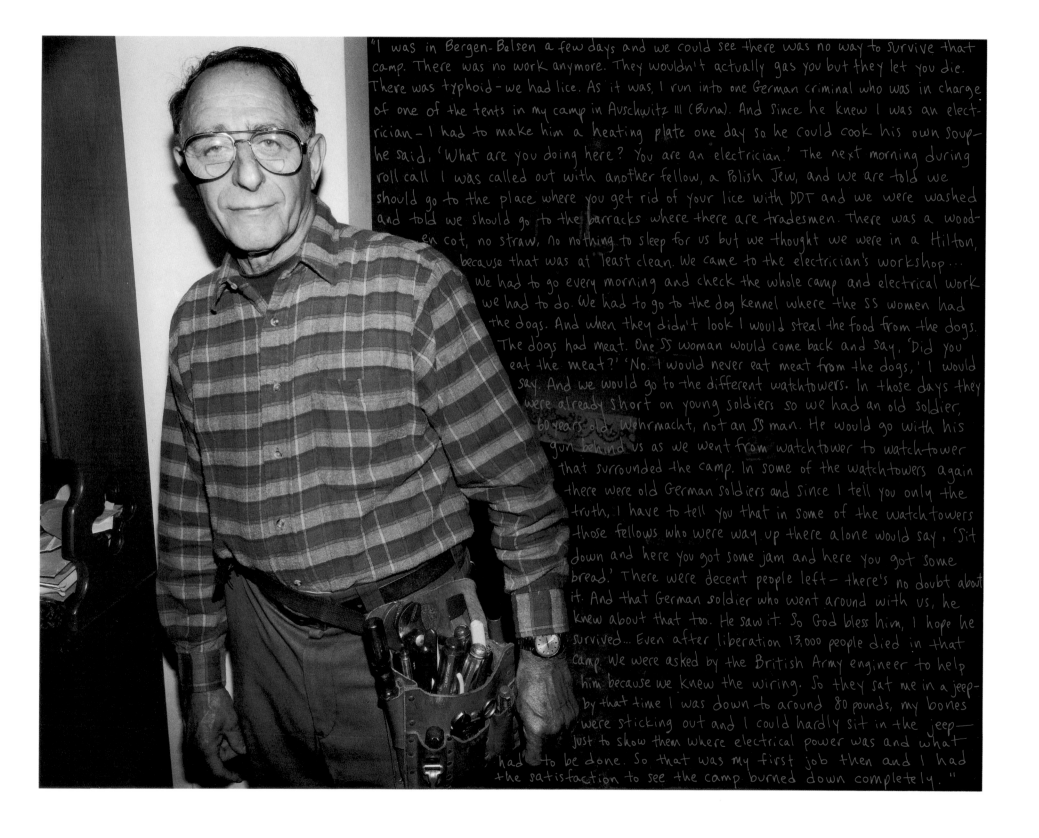

"I was in Bergen-Belsen a few days and we could see there was no way to survive that camp. There was no work anymore. They wouldn't actually gas you but they let you die. There was typhoid – we had lice. As it was, I run into one German criminal who was in charge of one of the tents in my camp in Auschwitz III (Buna). And since he knew I was an electrician – I had to make him a heating plate one day so he could cook his own soup – he said, 'What are you doing here? You are an electrician.' The next morning during roll call I was called out with another fellow, a Polish Jew, and we are told we should go to the place where you get rid of your lice with DDT and we were washed and told we should go to the barracks where there are tradesmen. There was a wooden cot, no straw, no nothing to sleep for us but we thought we were in a Hilton, because that was at least clean. We came to the electrician's workshop... We had to go every morning and check the whole camp and electrical work we had to do. We had to go to the dog kennel where the SS women had the dogs. And when they didn't look I would steal the food from the dogs. The dogs had meat. One SS woman would come back and say, 'Did you eat the meat?' 'No. I would never eat meat from the dogs,' I would say. And we would go to the different watchtowers. In those days they were already short on young soldiers so we had an old soldier, 60 years old, Wehrmacht, not an SS man. He would go with his gun behind us as we went from watchtower to watchtower that surrounded the camp. In some of the watchtowers again there were old German soldiers and since I tell you only the truth, I have to tell you that in some of the watchtowers those fellows who were way up there alone would say, 'Sit down and here you got some jam and here you got some bread.' There were decent people left – there's no doubt about it. And that German soldier who went around with us, he knew about that too. He saw it. So God bless him, I hope he survived... Even after liberation 13,000 people died in that camp. We were asked by the British Army engineer to help him because we knew the wiring. So they sat me in a jeep – by that time I was down to around 80 pounds, my bones were sticking out and I could hardly sit in the jeep – just to show them where electrical power was and what had to be done. So that was my first job then and I had the satisfaction to see the camp burned down completely."

After the war in Belgrade, 1953

RAFAEL PINTO

born 1934, Belgrade, Yugoslavia

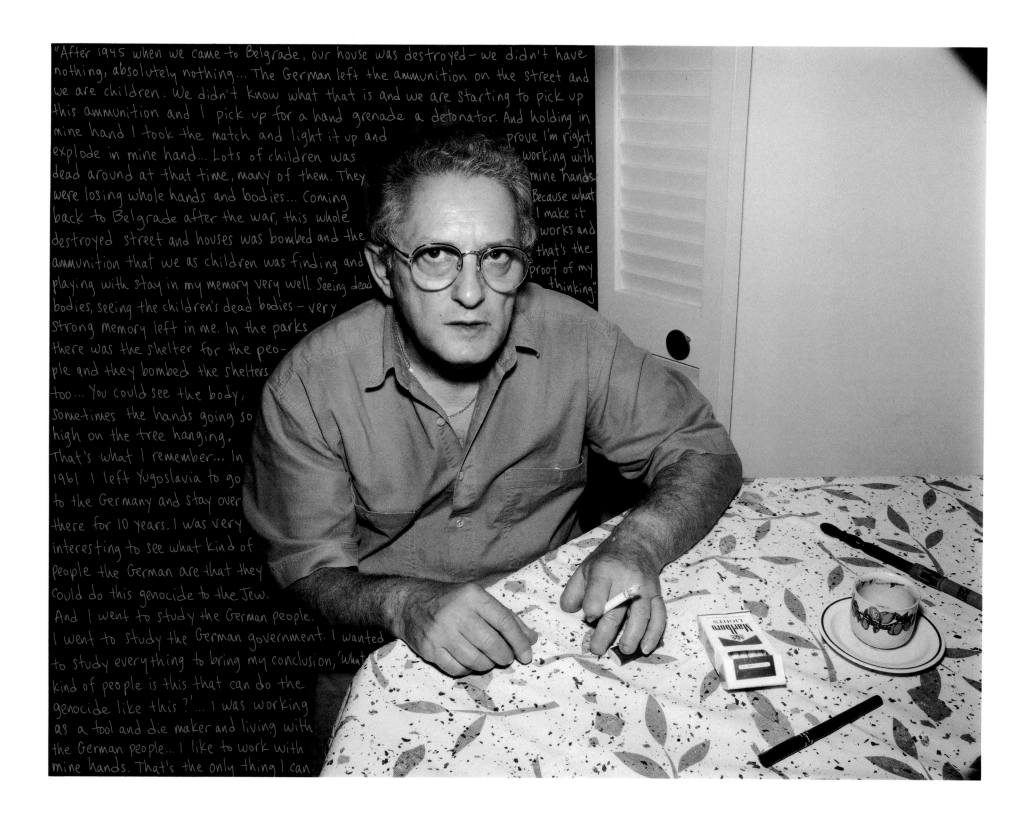

"After 1945 when we came to Belgrade, our house was destroyed—we didn't have nothing, absolutely nothing... The German left the ammunition on the street and we are children. We didn't know what that is and we are starting to pick up this ammunition and I pick up for a hand grenade a detonator. And holding in mine hand I took the match and light it up and prove I'm right, explode in mine hand... Lots of children was working with dead around at that time, many of them. They mine hands. were losing whole hands and bodies... Coming Because what back to Belgrade after the war, this whole I make it destroyed street and houses was bombed and the works and ammunition that we as children was finding and that's the playing with stay in my memory very well. Seeing dead proof of my bodies, seeing the children's dead bodies—very thinking." strong memory left in me. In the parks there was the shelter for the peo- ple and they bombed the shelters too... You could see the body, sometimes the hands going so high on the tree hanging. That's what I remember... In 1961 I left Yugoslavia to go to the Germany and stay over there for 10 years. I was very interesting to see what kind of people the German are that they could do this genocide to the Jew. And I went to study the German people. I went to study the German government. I wanted to study everything to bring my conclusion, 'what kind of people is this that can do the genocide like this?'... I was working as a tool and die maker and living with the German people... I like to work with mine hands. That's the only thing I can

In a camp near Rome, 1949

ESTHER LEVY

born 1925, Cluj, Romania

(Also pictured is Yitzchak Suchowolski)

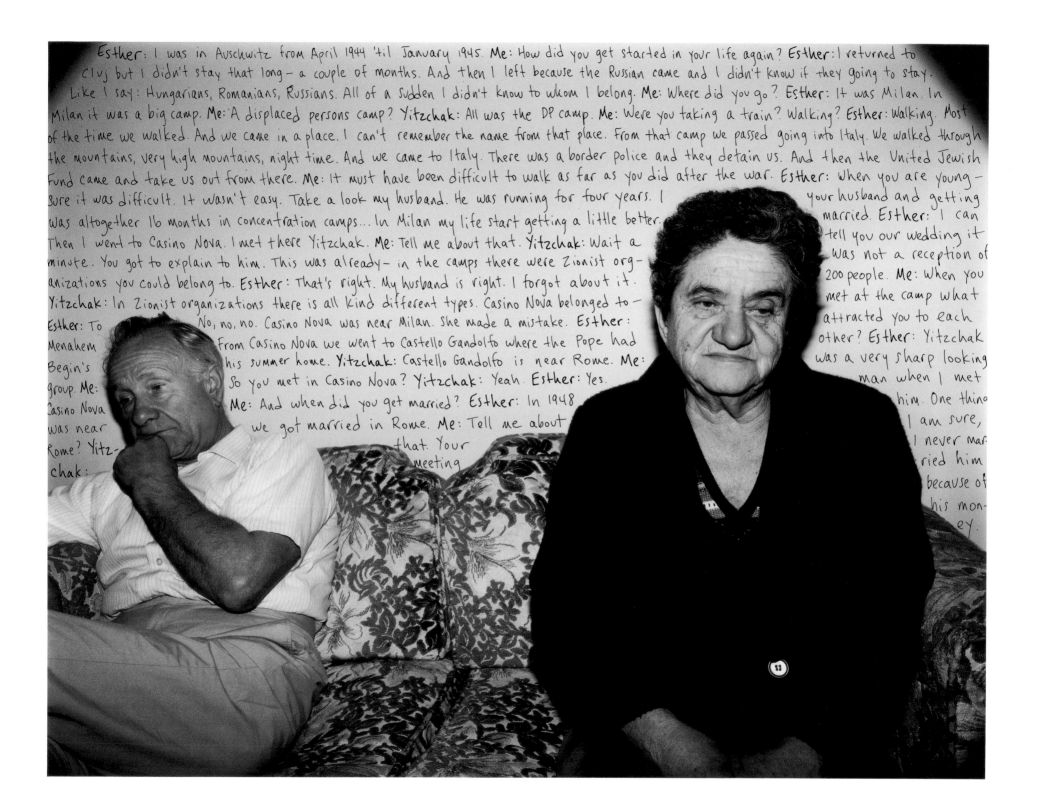

Esther: I was in Auschwitz from April 1944 'til January 1945. Me: How did you get started in your life again? Esther: I returned to Cluj but I didn't stay that long—a couple of months. And then I left because the Russian came and I didn't know if they going to stay. Like I say: Hungarians, Romanians, Russians. All of a sudden I didn't know to whom I belong. Me: Where did you go? Esther: It was Milan. In Milan it was a big camp. Me: A displaced persons camp? Yitzchak: All was the DP camp. Me: Were you taking a train? Walking? Esther: Walking. Most of the time we walked. And we came in a place. I can't remember the name from that place. From that camp we passed going into Italy. We walked through the mountains, very high mountains, night time. And we came to Italy. There was a border police and they detain us. And then the United Jewish Fund came and take us out from there. Me: It must have been difficult to walk as far as you did after the war. Esther: When you are young—sure it was difficult. It wasn't easy. Take a look my husband. He was running for four years. I was altogether 16 months in concentration camps... In Milan my life start getting a little better. Then I went to Casino Nova. I met there Yitzchak. Me: Tell me about that. Yitzchak: Wait a minute. You got to explain to him. This was already—in the camps there were Zionist organizations you could belong to. Esther: That's right. My husband is right. I forgot about it. Yitzchak: In Zionist organizations there is all kind different types. Casino Nova belonged to—Esther: To Menahem Begin's group. Me: Casino Nova was near Rome? Yitzchak: No, no, no. Casino Nova was near Milan. She made a mistake. Esther: From Casino Nova we went to Castello Gandolfo where the Pope had his summer home. Yitzchak: Castello Gandolfo is near Rome. Me: So you met in Casino Nova? Yitzchak: Yeah. Esther: Yes. Me: And when did you get married? Esther: In 1948 we got married in Rome. Me: Tell me about that. Your meeting your husband and getting married. Esther: I can tell you our wedding it was not a reception of 200 people. Me: When you met at the camp what attracted you to each other? Esther: Yitzchak was a very sharp looking man when I met him. One thing I am sure, I never married him because of his money.

(left) *Taken in 1938 in Germany within a year
before I came to this country*
(below) *As a 1st Lieutenant in Paris in 1945*

FRITZ H. GOLDBACH

born 1919, Marktbreit, Germany

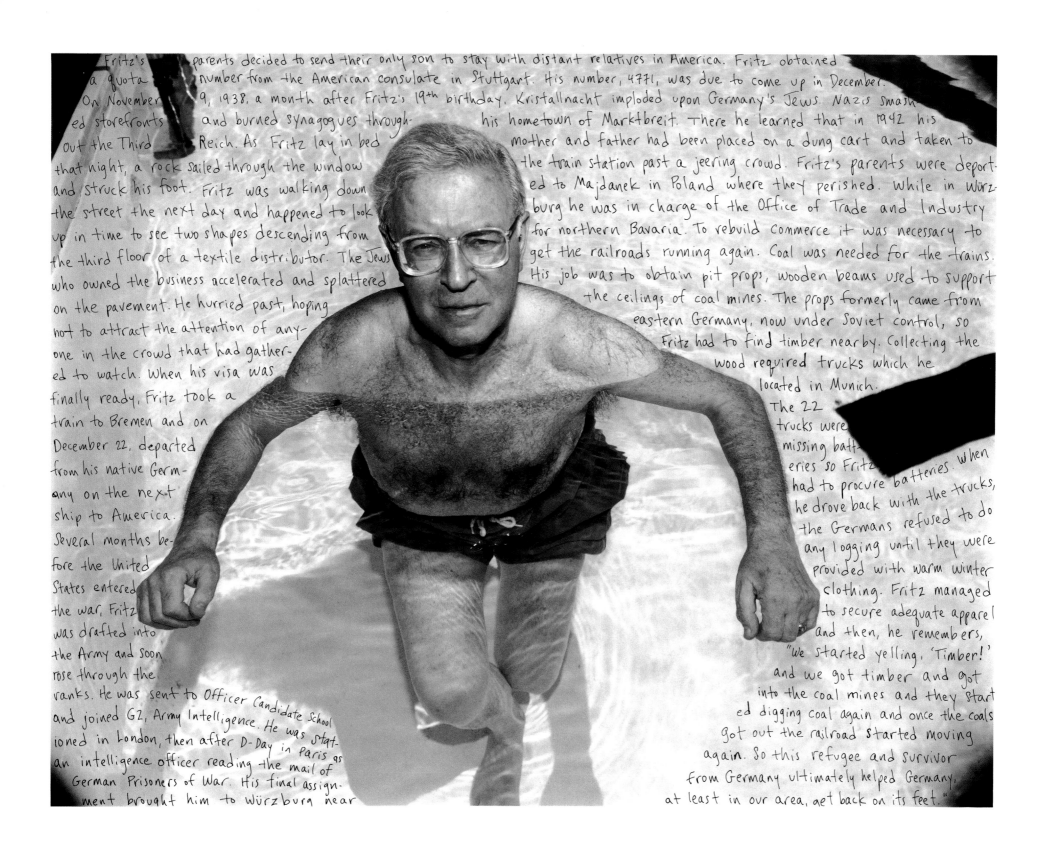

Fritz's parents decided to send their only son to stay with distant relatives in America. Fritz obtained a quota number from the American consulate in Stuttgart. His number, 4771, was due to come up in December. On November 9, 1938, a month after Fritz's 19th birthday, Kristallnacht imploded upon Germany's Jews. Nazis smashed storefronts and burned synagogues throughout the Third Reich. As Fritz lay in bed that night, a rock sailed through the window and struck his foot. Fritz was walking down the street the next day and happened to look up in time to see two shapes descending from the third floor of a textile distributor. The Jews who owned the business accelerated and splattered on the pavement. He hurried past, hoping not to attract the attention of anyone in the crowd that had gathered to watch. When his visa was finally ready, Fritz took a train to Bremen and on December 22, departed from his native Germany on the next ship to America. Several months before the United States entered the war, Fritz was drafted into the Army and soon rose through the ranks. He was sent to Officer Candidate School and joined G2, Army Intelligence. He was stationed in London, then after D-Day in Paris as an intelligence officer reading the mail of German Prisoners of War. His final assignment brought him to Würzburg near his hometown of Marktbreit. There he learned that in 1942 his mother and father had been placed on a dung cart and taken to the train station past a jeering crowd. Fritz's parents were deported to Majdanek in Poland where they perished. While in Würzburg he was in charge of the Office of Trade and Industry for northern Bavaria. To rebuild commerce it was necessary to get the railroads running again. Coal was needed for the trains. His job was to obtain pit props, wooden beams used to support the ceilings of coal mines. The props formerly came from eastern Germany, now under Soviet control, so Fritz had to find timber nearby. Collecting the wood required trucks which he located in Munich. The 22 trucks were missing batteries so Fritz had to procure batteries. When he drove back with the trucks, the Germans refused to do any logging until they were provided with warm winter clothing. Fritz managed to secure adequate apparel and then, he remembers, "We started yelling, 'Timber!' and we got timber and got into the coal mines and they started digging coal again and once the coals got out the railroad started moving again. So this refugee and survivor from Germany ultimately helped Germany, at least in our area, get back on its feet."

(right) *The Isle of Levant in the Mediterranean, summer, 1939*

(below) *Just after my marriage in October, 1942 in Marseille*

VIVETTE HERMANN

born 1919, Paris, France

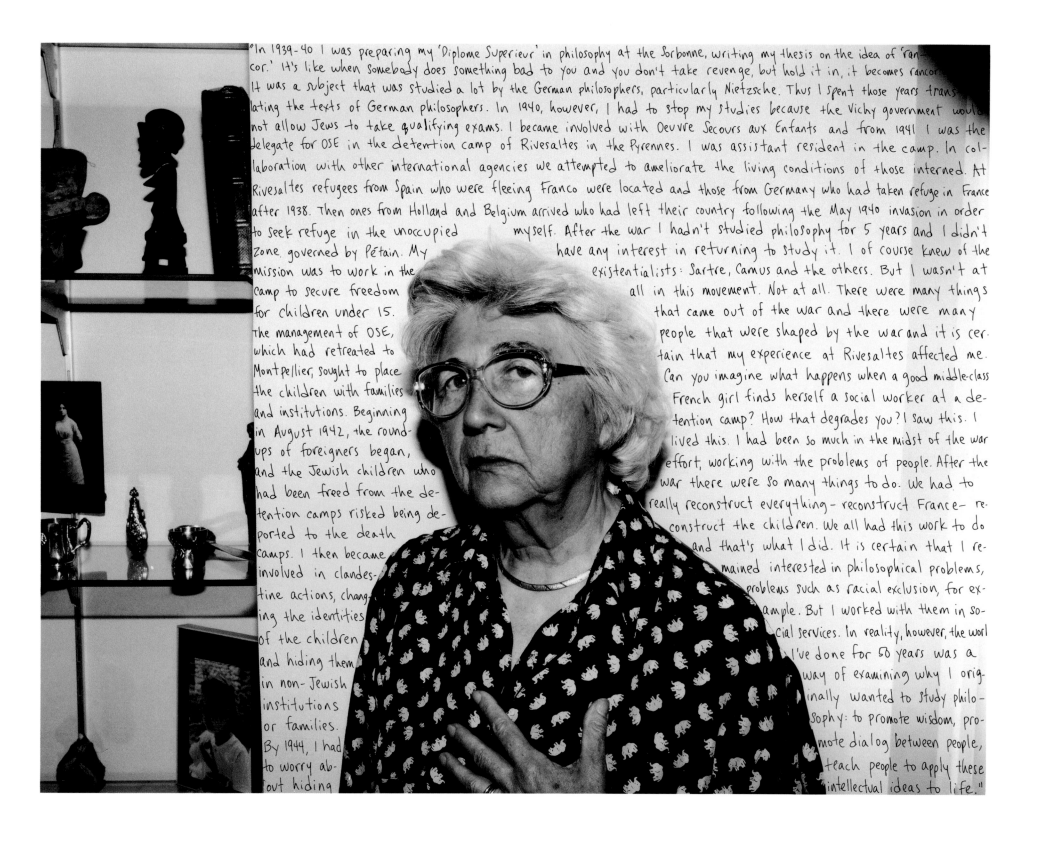

"In 1939-40 I was preparing my 'Diplome Superieur' in philosophy at the Sorbonne, writing my thesis on the idea of 'rancor.' It's like when somebody does something bad to you and you don't take revenge, but hold it in, it becomes rancor. It was a subject that was studied a lot by the German philosophers, particularly Nietzsche. Thus I spent those years translating the texts of German philosophers. In 1940, however, I had to stop my studies because the Vichy government would not allow Jews to take qualifying exams. I became involved with Oeuvre Secours aux Enfants and from 1941 I was the delegate for OSE in the detention camp of Rivesaltes in the Pyrennes. I was assistant resident in the camp. In collaboration with other international agencies we attempted to ameliorate the living conditions of those interned. At Rivesaltes refugees from Spain who were fleeing Franco were located and those from Germany who had taken refuge in France after 1938. Then ones from Holland and Belgium arrived who had left their country following the May 1940 invasion in order to seek refuge in the unoccupied zone governed by Pétain. My mission was to work in the camp to secure freedom for children under 15. The management of OSE, which had retreated to Montpellier, sought to place the children with families and institutions. Beginning in August 1942, the round-ups of foreigners began, and the Jewish children who had been freed from the detention camps risked being deported to the death camps. I then became involved in clandestine actions, changing the identities of the children and hiding them in non-Jewish institutions or families. By 1944, I had to worry about hiding myself. After the war I hadn't studied philosophy for 5 years and I didn't have any interest in returning to study it. I of course knew of the existentialists: Sartre, Camus and the others. But I wasn't at all in this movement. Not at all. There were many things that came out of the war and there were many people that were shaped by the war and it is certain that my experience at Rivesaltes affected me. Can you imagine what happens when a good middle-class French girl finds herself a social worker at a detention camp? How that degrades you? I saw this. I lived this. I had been so much in the midst of the war effort, working with the problems of people. After the war there were so many things to do. We had to really reconstruct everything - reconstruct France - reconstruct the children. We all had this work to do and that's what I did. It is certain that I remained interested in philosophical problems, problems such as racial exclusion, for example. But I worked with them in social services. In reality, however, the work I've done for 50 years was a way of examining why I originally wanted to study philosophy: to promote wisdom, promote dialog between people, teach people to apply these intellectual ideas to life."

*Taken in Debrecen in the winter of 1943–44 for a permit
we had to carry with us for identification.*

AGNES WEISZ

born 1925, Debrecen, Hungary

On a cloudy Sunday in March, 1944, the German Army marched into Debrecen, Hungary. By April 5, Agnes Weisz, who was nineteen at the time, and her family were forced to wear a yellow Jewish star on their clothes whenever they went outside. Her father, who was an officer in the Hungarian Army, had been dismissed from his post earlier. Worse for Agi's family, he was fired from his job as sales representative for a farm implement company. Conditions for the Weiszs began to deteriorate rapidly. On May 6 they were herded together into a crowded ghetto where they remained a month. As her family was marched through the streets by armed guards, a girl whom Agi knew from Catholic high school picked up a rock and threw it at her.

On June 8 the Weisz family was taken with hundreds of other Jews to a brick factory along a railroad siding. A few days later they were all loaded into cattle cars and after a trip in the general direction of Auschwitz, they were rerouted to Vienna, Austria. From June 1944 until March 1945 Agi carried mortar to repair buildings damaged by Allied bombs. During this time her family's meager rations were supplemented by gifts of food from Viennese civilians.

In March 1945 most of the surviving Jews from Debrecen were loaded onto a train headed for Bergen-Belsen, a death camp inside Germany. While waiting on a railroad siding at Strasshof, a camp outside Vienna, they were caught in an air raid. A siren sounded as the Allies attacked. Bombs fell all around the wagon in which the Weiszs were huddled beneath their father's protective embrace. Miraculously none of the cars carrying Jews was hit, though trains all around were overturned, and tracks rolled up like cooked fettucini. By morning the SS guards had fled and the Russian Army entered Strasshof. The liberators greeted the Jews by raping women and stealing supplies.

Nevertheless Agi and her immediate family survived and began the week-long walk home. A less fortunate cousin was killed on his trek from Strasshof to Debrecen. The Weiszs moved back into their house which had been looted by townspeople.

In 1946, just before the Iron Curtain fell, stranding the rest of her family, Agi took the long train ride from Hungary to France, boarded a steamship at Le Havre, and arrived alone in America.

Photo taken June 7, 1946 in Rotz, Germany

DAVID FIGMAN

born 1926, Warsaw, Poland

"They caught one prisoner, a German Jew, and he had a can with a false bottom. This German-American SS guard was in charge of us at the camp at Budzyn and he opened the can and found gold pieces. You know what they did to this prisoner? They put an electric wire around his throat and one to his penis. And we had to kill him. Do you believe this? The Jews had to kill him. They had us wrap the wire around him, electric wire to his penis and his throat. He was spinning around and everyone got to hit him — killed him right away. It's a shame to tell this. The Jews had to kill somebody. It's not easy to talk about. Before this the Germans killed a couple of other prisoners who refused to cooperate. They said to us, 'If you don't do it we'll kill you too.'... I was liberated in Germany. I was a young man. I went to Israel and fought in two wars, in 1948 and 1956. I could have come to the US straight from Germany in 1945 but I said, 'No. I better go first to Israel and fight by the Israeli Army.' We went from Germany to France to an army base in Marseilles. We created an army from people who survived in Russia. We were there a couple of months, maybe a year, and everyone was studying how to operate a machine gun. When we got to Israel we were already an army that could fight the Arabs. In 1948 it was a nice war, beautiful war. Our army was stretched so thin — we didn't have enough soldiers to cover all the fronts. We didn't have enough rifles or ammunition. There were two rifles for every ten people. We were so happy to find out the Jordanians nearby got the artillery and didn't use it even. We went in there during the night and took everything from them while they were sleeping. And so we survived 1948 with a little army. 99% was boys from the camps, from the Holocaust."

Chicago, 1950

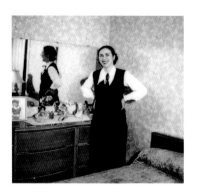

DORA MIZUTZ

born 1914, Rovno, Poland

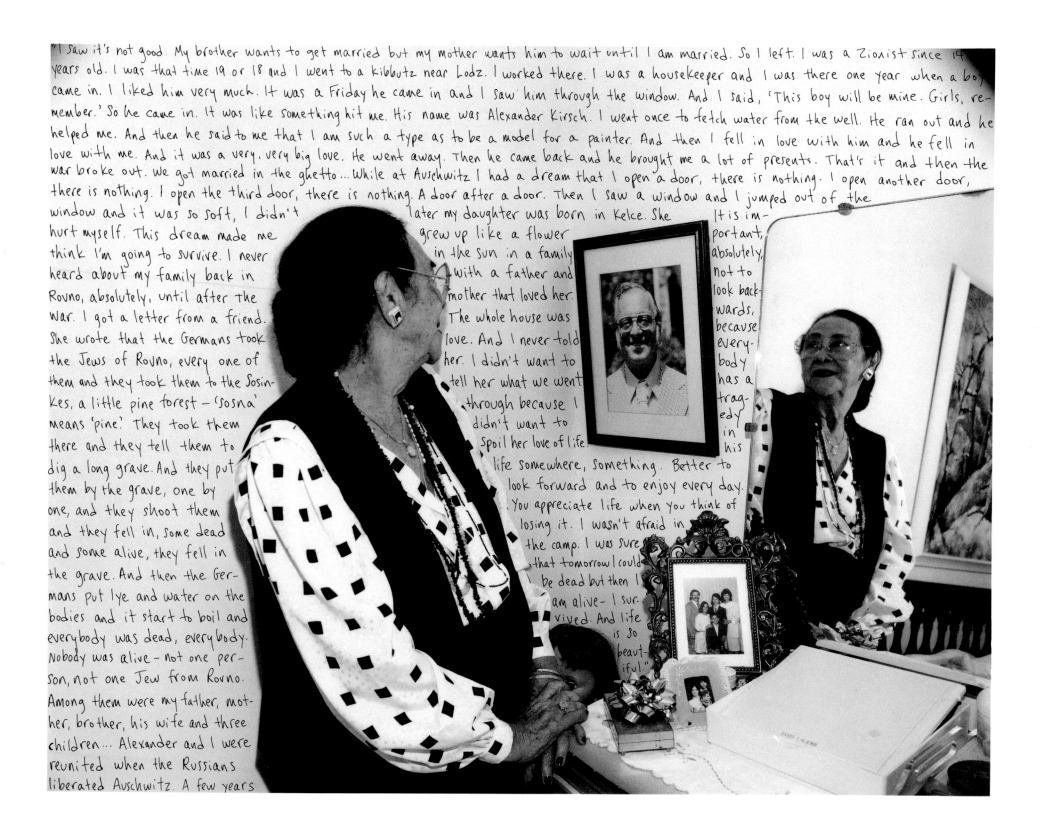

"I saw it's not good. My brother wants to get married but my mother wants him to wait until I am married. So I left. I was a Zionist since 14 years old. I was that time 19 or 18 and I went to a kibbutz near Lodz. I worked there. I was a housekeeper and I was there one year when a boy came in. I liked him very much. It was a Friday he came in and I saw him through the window. And I said, 'This boy will be mine. Girls, remember.' So he came in. It was like something hit me. His name was Alexander Kirsch. I went once to fetch water from the well. He ran out and he helped me. And then he said to me that I am such a type as to be a model for a painter. And then I fell in love with him and he fell in love with me. And it was a very, very big love. He went away. Then he came back and he brought me a lot of presents. That's it and then the war broke out. We got married in the ghetto... While at Auschwitz I had a dream that I open a door, there is nothing. I open another door, there is nothing. I open the third door, there is nothing. A door after a door. Then I saw a window and I jumped out of the window and it was so soft, I didn't hurt myself. This dream made me think I'm going to survive. I never heard about my family back in Rovno, absolutely, until after the war. I got a letter from a friend. She wrote that the Germans took the Jews of Rovno, every one of them and they took them to the Sosinkes, a little pine forest — 'sosna' means 'pine.' They took them there and they tell them to dig a long grave. And they put them by the grave, one by one, and they shoot them and they fell in, some dead and some alive, they fell in the grave. And then the Germans put lye and water on the bodies and it start to boil and everybody was dead, everybody. Nobody was alive — not one person, not one Jew from Rovno. Among them were my father, mother, brother, his wife and three children... Alexander and I were reunited when the Russians liberated Auschwitz. A few years later my daughter was born in Kelce. She grew up like a flower in the sun in a family with a father and mother that loved her. The whole house was love. And I never told her. I didn't want to tell her what we went through because I didn't want to spoil her love of life. It is important, absolutely, not to look backwards, because everybody has a tragedy in his life somewhere, something. Better to look forward and to enjoy every day. You appreciate life when you think of losing it. I wasn't afraid in the camp. I was sure that tomorrow I could be dead but then I am alive — I survived. And life is so beautiful."

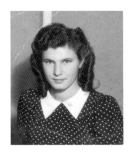

(left) *Sweden, Summer, 1945.*
First picture taken after the war while in quarantine.
(below) *Tomaszow-Maz, July 1942.*
Only two survived the war, Jumek Wald and me.
All the others were killed.

JADZIA STRYKOWSKA

born 1924, Tomaszow-Maz, Poland

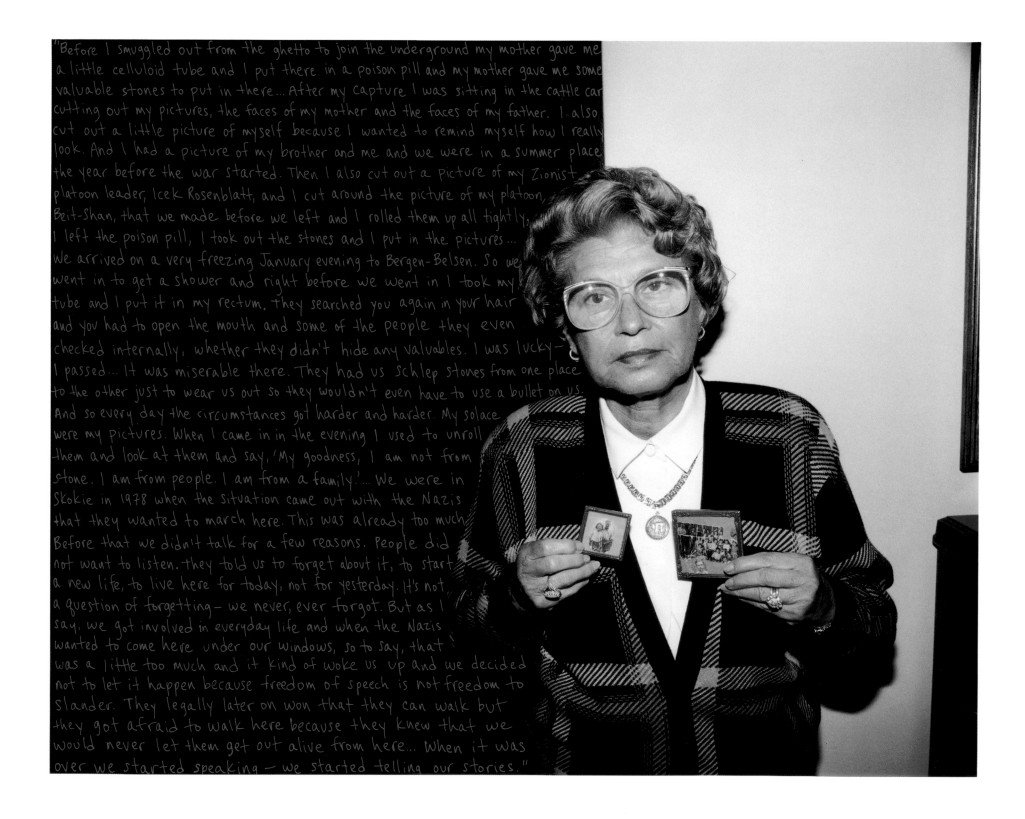

"Before I smuggled out from the ghetto to join the underground my mother gave me a little celluloid tube and I put there in a poison pill and my mother gave me some valuable stones to put in there... After my capture I was sitting in the cattle car cutting out my pictures, the faces of my mother and the faces of my father. I also cut out a little picture of myself because I wanted to remind myself how I really look. And I had a picture of my brother and me and we were in a summer place the year before the war started. Then I also cut out a picture of my Zionist platoon leader, Icek Rosenblatt, and I cut around the picture of my platoon, Beit-Shan, that we made before we left and I rolled them up all tightly, I left the poison pill, I took out the stones and I put in the pictures... We arrived on a very freezing January evening to Bergen-Belsen. So we went in to get a shower and right before we went in I took my tube and I put it in my rectum. They searched you again in your hair and you had to open the mouth and some of the people they even checked internally, whether they didn't hide any valuables. I was lucky— I passed... It was miserable there. They had us schlep stones from one place to the other just to wear us out so they wouldn't even have to use a bullet on us. And so every day the circumstances got harder and harder. My solace were my pictures. When I came in in the evening I used to unroll them and look at them and say, 'My goodness, I am not from stone. I am from people. I am from a family.'... We were in Skokie in 1978 when the situation came out with the Nazis that they wanted to march here. This was already too much. Before that we didn't talk for a few reasons. People did not want to listen, they told us to forget about it, to start a new life, to live here for today, not for yesterday. It's not a question of forgetting— we never, ever forgot. But as I say, we got involved in everyday life and when the Nazis wanted to come here under our windows, so to say, that was a little too much and it kind of woke us up and we decided not to let it happen because freedom of speech is not freedom to slander. They legally later on won that they can walk but they got afraid to walk here because they knew that we would never let them get out alive from here... When it was over we started speaking — we started telling our stories."

Order of Plates

The second photo was taken by the U.S. Army after I escaped from the last concentration camp

(Landsberg), sub-camp of Dachau. This photograph was taken in France.

This was an Army camp named Camp Lucky Strike. When I escaped from the Nazis I was fortunate

to be picked up by the U.S. Army. I stayed with the Army until I was able to come to the U.S.

MISO VOGEL

Afterword

There was a lot of talk about the Holocaust during my childhood in a Jewish community in suburban New York. My grandparents, immigrants from Eastern Europe, became furious whenever conversation turned to Hitler and the Germans. My mother's parents grew up in Lublin, Poland. Her father had a brother and a sister who remained behind in the Old Country when he emigrated to the United States early in this century. His sister had twins. My grandfather was unable to find out exactly what happened to his family, but they did not survive the war.

In 1988 I made a photograph with inscribed text of Miso Vogel, an Auschwitz survivor living in Indiana. For the narrative I used notes I had taken while talking with him during our portrait session. I wanted to show his tattoo, which is in and of itself a powerful visual statement about the brutality of the German war against the Jews. I also had him hold a photograph of his father who died at Auschwitz. This image acted as a window and Miso was, for a moment, transported back to a terrible time in his past.

During my year off from teaching as a Guggenheim Fellow in 1991–92, I decided to build a series of images around the photograph of Miso. I began each session with survivors by videotaping them prior to making portraits with my still camera. Instead of rewriting accounts of the survivors in my own words as in the earliest pieces from the series, I began to excerpt whole chunks of the testimonies verbatim, letting the individuals speak for themselves. In so doing I tried to keep the flavor of the European accents, which often reminded me of the speech of my own grandparents. I looked for small, intimate details in their narratives rather than grander, more general experiences or statistical data.

I am fully aware that no one who did not directly experience the Holocaust can truly understand the depths of horror that Jews in Europe endured at the hands of the Nazis. Nevertheless, it is my hope that by opening a window to an individual through his or her image with an accompanying story of great power, an audience will gain a better understanding of the survivors.

Faced with the loss of home and family and confronting a future in a strange land with new language and customs, many of the survivors I met had learned to live with their pain. Most were able to move their lives forward, deciding that life is too short and precious to be consumed with hatred and remorse. This work is a testament to the strength of the individual and to the resourcefulness and resiliency of Holocaust survivors, who have an important lesson in humanity to teach us all.

Acknowledgements

96 *I would like to thank the following individuals and organizations for their generous help and support: David Breskin, San Francisco, for bringing this work to the attention of Chronicle Books; Lillian Gerstner, Carla Grenten, Myrtle Figman and Erna Ganz of the Holocaust Memorial Foundation, Skokie, Illinois, for putting me in touch with Chicago-area survivors; Char Seltzer of Jewish Family & Children's Services, Indianapolis; Marcia Goldstone, Director, Jewish Community Relations Council, Indianapolis; Alvin Rosenfeld, Director, Jewish Studies, Indiana University; Jeffrey Alberts, Associate Dean of Research at Indiana University, for his assistance in obtaining publication subvention funds; Alex Mouton and Judit Horvath, both of Indiana University, for their German and Hungarian translations, respectively—Alex also helped enormously in sequencing these photographs; Jim Starrt in Paris, for his many hours of help with French interviews and translations; David Travis at the Art Institute of Chicago and Charles Stainback of the International Center of Photography for sharing their critical eyes with me; Mort Lowengrub, Dean of the College of Arts and Sciences at Indiana University, for his constant support.*

Fellowships from the John Simon Guggenheim Memorial Foundation and the National Endowment for the Arts provided timely financial support as this work evolved. In addition a U.S./France Fellowship from the National Endowment for the Arts for a four-month residency in Paris helped me extend the project to Europe as did an ArtsLink Fellowship, which gave me the opportunity to travel to Czechoslovakia. I am especially indebted to G. Thomas Tanselle of the Guggenheim Foundation for providing a subvention grant to assist in the publication of this book.

I am grateful to the staff at Chronicle Books, especially Jill Jacobson for her design of the book; Emily Miller spent many hours helping me edit and shape its contents; Caroline Herter saw this project through from start to finish. Her strong encouragement from the beginning will always be appreciated.

Catherine Edelman deserves my lasting gratitude for her years of support on this and other projects. Her thoughtful advice and candid criticism of my work have been invaluable.

My wife, Betsy Stirratt, has influenced me greatly over the years. I often relied upon her aesthetic judgements at critical junctures in the making of this series of photographs.

Finally and most important, I am indebted to the survivors themselves who agreed to share with me some of their most intimate and tragic experiences.

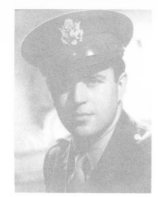
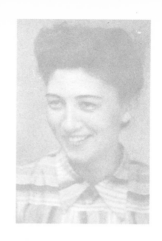
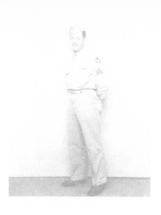
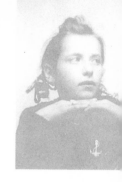
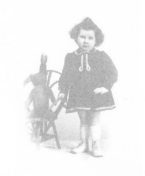
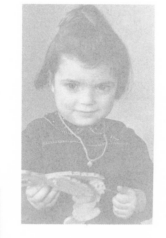
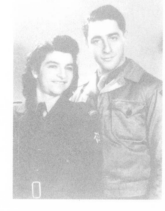
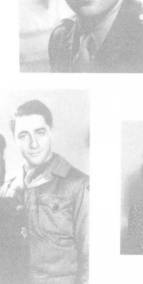

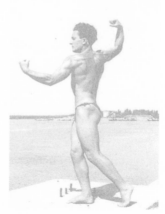

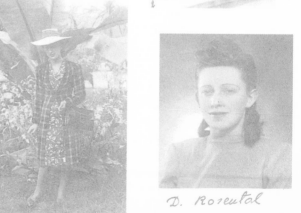
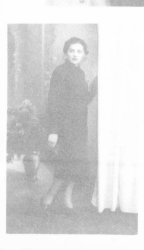
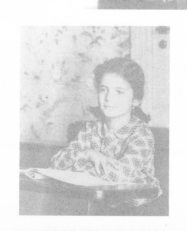

D. Rosenthal

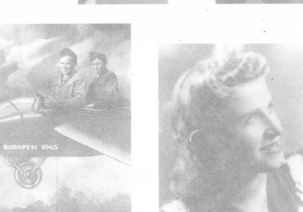

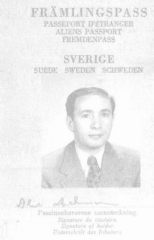
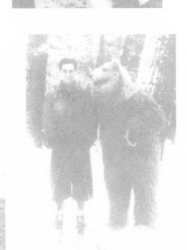
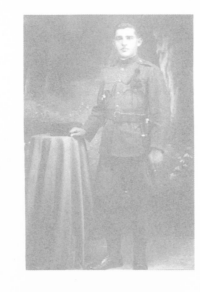

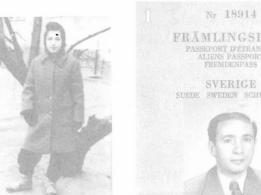
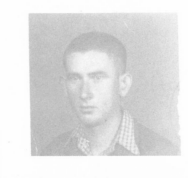
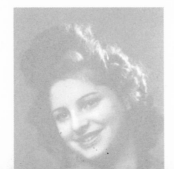
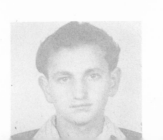
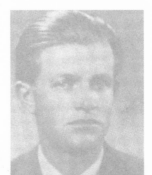

BUDAPEST 1945

Nr 18914

FRÄMLINGSPASS
PASSEPORT D'ÉTRANGER
ALIENS PASSPORT
FREMDENPASS

SVERIGE
SUÈDE SWEDEN SCHWEDEN

Passinnehavarens namnteckning.
Signature du titulaire.
Signature of holder.
Unterschrift des Inhabers.